Cubism and Futurism

Phaidon 20th-century Art

With sixty-four colour reproductions of works by:

Balla	Gleizes	Marcoussis
Boccioni	Goncharova	Metzinger
Braque	Gris	Mondrian
Carrà	Kupka	Picabia
Cézanne	La Fresnaye	Picasso
Delaunay	Léger	Russolo
Delaunay-Terk	MacDonald-Wright	Severini
Derain	Malevich	Villon
Duchamp	Marc	

Maly and Dietfried Gerhardus

Cubism and Futurism

The evolution of the self-sufficient picture

Phaidon · Oxford

Contents

The authors and publisher wish to thank the staff of the museums and galleries that have allowed works to be reproduced in this book.

Translated by John Griffiths

Phaidon Press Limited, Littlegate House, St Ebbe's Street, Oxford
First published in Great Britain 1979
Published in the United States of America
by E. P. Dutton, New York.
Originally published as *Kubismus und Futurismus*
© 1977 by Smeets Offset BV, Weert, The Netherlands
German text © 1977 by Verlag Herder, Freiburg im Breisgau
English translation © 1979 by Phaidon Press Limited
Illustrations © Beeldrecht, Amsterdam.

ISBN 0 7148 1953 0
Library of Congress Catalog Card Number
78–24648

Printed in The Netherlands by Smeets Offset BV, Weert

Are Cubist paintings artistic puzzles?

It is not easy to understand and appreciate Cubist and Futurist paintings. The following description is exemplary of the process of coming to terms with the art of the first quarter of the twentieth century. It should be borne in mind throughout the book.

Picasso's 1912 painting *The Torero or the Aficionado* (Ill. 8) is a good example of the problems raised by Cubism. To an unprepared and unprejudiced observer, even after his first impression, the picture seems to bear very little relationship to the objects of the ordinary visual world it is supposed to refer to. He is inclined to rely on his normal way of looking at things, on the perception that helps him deal with most situations, as an adequate approach to any painting; so why not this one? He tries to use the title as an aid to understanding: *The Torero or the Aficionado* (*Le Toréro ou l'Aficionado*). But what it might lead him to expect from the painting isn't there. The title refers to two different persons: one of the people taking an active part in the bull-ring, a torero, *and* an 'aficionado' or bull-fighting fan who stands for enthusiasm and expertise and often follows the progress of a (usually young) matador. The 'active' matador and 'passive' spectator are equally characteristic of the bull-fight.

But the observer asks, of course, what actual parts of the painted picture refer to a torero or a fan. For the painting and the title don't seem to fit one another when he relies on his usual way of interpreting things, which is largely the method usually sufficient for dealing with the everyday world. For instance, even if he has been to a bull-fight in Spain nothing in the picture reminds him of what he saw there: a famous matador, a specific bull-ring, and so on. There is no torero and no spectator; there is no arena, no grand-stand nor seats, no bull and no horses.

Perhaps the painter chose the title in order to deceive the observer and make him assume from the start that the painting contained a figurative image of someone connected with bull-fighting – or even two such people? In which case, instead of viewing the picture in the simplest way as something referring directly to things in the ordinary everyday world, the observer would assume that Picasso was the kind of painter who used trick-titles as a stratagem to get people 'into' the work.

If the observer does not know much about Cubist painting, even though he might retain his interest in it, he will only be able to take the title as a general indication of the rough field of topics to which the picture refers. He will treat it rather like the titles of novels, short stories and poems. For instance, in

Wallace Stevens' poem *Dry Loaf* and W. B. Yeats's *The Long-Legged Fly* an actual loaf and fly are not 'reproduced' by means of verbal counters. Similarly, Picasso's painting does not offer a mere photograph, as it were, of a torero or a fan in order to refer to some typical situation to be met with in the ring. Instead, the observer is required to use the hints afforded by the title as guidance to what is actually to be seen in the picture. In other words, he is asked to look into the picture for its individual elements, structure and artistic technique, and to observe its construction as a work of art 'pure and simple'.

Here there seems to be a point of comparison with the find-the-picture kind of puzzle, and indeed the analogy is useful if it is not pursued too far. In both cases the observer is required to study the overall connexion and interrelation of the basic elements of the picture. In the puzzle this is done by means of an emphatic caption, which might be, for example, 'Where is the hunter?' The observer is given some helpful advice: 'If you look at this picture long enough and in the right way you will eventually find a hunter.' Whereas the puzzle consists of drawn elements which depend on the normal processes of perception for their resolution (only a few are difficult or hidden and most of them are easily ascertainable), the configuration of Picasso's *Torero* reveals a dichotomy between what are for the most part visually unfamiliar elements and a few recognizable details which normal perception can grasp at. But both the puzzle and the Cubist painting are structurally conceived so as to require the observer to scrutinize the picture itself with the utmost care. In the puzzle he does so and finally discerns, perhaps, in a tangle of branches the outline of a figure with a hat, gun, rucksack and dog. In the case of the Cubist painting, he starts from the thematic hints in the title and looks at every individual element of the picture's alien structure. He is trying to abandon his expectation that he will merely have to acknowledge the known and conventional, and to replace it by a state of perception that demands scrutiny of each painted component. When one looks at a Cubist painting one should remember that on reading a text in a language one knows well, one does not consciously attend to each word; it would be too much unnecessary trouble to decipher the meaning of familiar words: instead one is usually content to recognize them generally in the lightning process of reading.

In the case of Picasso's painting we notice parts of a figure (the suggestion of a face, moustaches and mouth, perhaps), and certainly the barbed hook in the lower third of the picture (right) or the nails in the upper third (left). Like the nails and their shadows at the upper edge of Braque's 1909–1910 *Violin and Jug* and *Violin and Palette*,[1] these objects have been painted with photographic accuracy. There are also some odd intrusions of painted letters and words: for instance, 'LE TORERO' and 'MAN' in the lower half of the picture or 'Nimes' at top left.

The comparison with the puzzle picture shows that Cubist painting stresses the distinction between recognizing what is known and perceptive cognition of the unexperienced and unknown, whereas the puzzle asks us to look in what is known for something we also already know quite well. In the puzzle, the drawn branches form part of the outline of the figure we are looking for, and its finding is the criterion for ceasing to be interested in the picture. The Cubist painting is also comparable with the puzzle picture in that the drawn element, the sketching, of the puzzle is usually predominant – not only because colour is too expensive but because it would detract from the clarity of the design. In Picasso's work, too, linear elements play the main part. The colours are reduced to a restrained grey-brown range, apart from a few touches of green at bottom centre corresponding with the reddish-brown in the upper half of the painting. Otherwise the painted lines, angles and planes are the structural elements of the picture, but define much more than mere lines, angles and planes. There is, however, no criterion for knowing when the picture is 'finished'. In that respect a Cubist painting differs from a puzzle-picture. There are nevertheless devices the observer can latch on to. For instance,

6

if he looks up the word 'Nimes' in an encyclopaedia, he will probably discover that it is the name of a town in the south of France with a Roman amphitheatre where bull-fights are still held. Or, if necessary, he will read a monograph on the ceremonial and procedure of a bull-fight and discover that the weapon with a metal barb is one of the banderillas stuck in the muscular nape of the bull's neck.

This Cubist painting shows how it is intended to coax the observer into a constant, active search for a connexion between direct seeing and knowing. The process of perception is, at least in principle, always open, always unfinished. Each successfully completed stage of observation not only relates vision to knowledge but opens up new possibilities of vision. *The Torero or the Aficionado* is not a copy of a typical bull-fight scene (though Picasso did paint pictures that might be described thus); and it is not intended to be merely a kind of maze in which the observer picks out all the details related to bull-fighting. A painting of this kind is clearly intended to do more than provide the simple satisfaction of solving a puzzle-picture.

The rise of Cubist painting

Daniel Henry Kahnweiler played an extremely important part in the rise of Cubism. He was its first observer, critic, theoretician, patron and dealer. He was born in Mannheim in Germany and grew up in Stuttgart. In 1907, when he was twenty-three, he moved to Paris where he lived in the Rue Vignon. There, he opened a small gallery, which very soon became a major meeting-place for avant-garde artists and collectors. At first Kahnweiler tended to support the Fauves, and promoted mainly Maurice de Vlaminck, André Derain (Ill. 38) and Kees van Dongen. Later he concentrated on the painters in the Picasso circle, to whom his attention had been drawn by the collector and art critic Wilhelm Uhde. Together with the poet Guillaume Apollinaire, Kahnweiler was responsible, towards the end of 1907, for arranging a meeting between Picasso and Braque that was to have momentous results for the development and consolidation of Cubism. Kahnweiler's writings are still essential for an understanding of Cubism and its historical and theoretical standpoint. He was not satisfied with journalistic criticism, but, basing himself on meticulous observation and enthusiastic analysis of an art movement in full swing before his very eyes, he turned to questions of universal art theory and general aesthetics. He also possessed the natural gift of spontaneous judgment. The concepts, theories and insights that he evolved from close contact with the practical side of art have lost none of their extraordinary power of conviction and commitment. The events in the field of art in France between 1906 and 1914 can hardly be summarized more effectively than in Kahnweiler's own words:

'The post-Impressionism of the Fauves was nearly at an end. They had taken the painting of light to its extreme consequences. Whereas they still supposed that they were painting works imitative of nature, essentially representational works, art had become an orgy of colour that symbolized but did not imitate the external world. That was freedom but also license. The notion of a painting as a work of art disappeared. But some painters were aware that a picture ought to be a whole, a self-sufficient object. Georges Braque emerged from the ranks of the Fauves. He curbed his colour and strengthened his composition. In 1908 he produced his L'Estaque landscapes. They brought him close to Picasso who had arrived at roughly the same point by a different route. They had been baptized as 'Cubists'. What were they doing? On the one hand, they wanted to reaffirm the unity of the work of art; but, on the other hand, to say as much as possible about the objects they depicted. This period of Cubism, which ended round about 1914, may be called the *analytical* phase.'[2]

The first steps in understanding Cubism

Before amplifying some of Kahnweiler's points, it is important to clarify the distinction between 'imitation' and 'mere signification' of the visible external world. It is a distinction which proved to be especially decisive for Cubism and Futurism and, in fact, for the entire evolution of art in the twentieth century. Perhaps we will understand the problem, if we remember that, when looking at even highly imaginative, fantastic paintings, for instance those of Pieter Brueghel the younger, we can soon answer the question 'What does it show?' The same question, when asked of what is thought of as typically modern art, is, however, almost certainly a sign of the observer's puzzlement. Since he thinks the question is unanswerable, he often gives up the attempt to find out exactly what he is supposed to think when faced with a modern work of art.

The main reason for this uncertainty is of course that all our knowledge and experience are determined in some way by our previous linguistic understanding of the everyday world. This also happens when we look at things. 'The fact that we see verbally from childhood onwards is shown when a child draws "a man". He draws in series: "the head", "the neck", "the stomach", "the legs", "the arms", and so on; that is, he offers a plan of a man based on the verbally consolidated parts of a man as he remembers them from past experience'.[3] In other words: we do not learn to perceive, for perception as such is an inherited faculty, but we do learn to distinguish perceptions from one another, and do so precisely by means of linguistic hierarchies and divisions. If we take visual perception of this kind as the model for art, whatever the medium, and irrespective of whether it is 'realistic' or 'fantastic', we can speak of *imitative*, *mimetic* or *pure representational* art. The artist uses his own artistic presentation to imitate the visual world which he has not himself composed, and does so within the natural limitations of materials (canvas, paints, brushes, and so on) and available artistic means and techniques. As observers, we have no special problem in directly describing in terms drawn from our everyday speech what the painter has produced, as we are accustomed to do so every day in our encounters with the external world. Hence the sentence 'Grey-roofed houses cluster round the church' can be used as an adequate description of a village on a hillside, and of a painting of the same place.

The less applicable this basis of conventional perception is to works of art, the less representational content they have. Pictures in which the painter is increasingly prepared to discard imitation, allow the notion of the autonomy of the painting to become predominant. This can be seen, for example, in Kupka's *Newtonian Colour Disks* (Ill. 36) and *Vertical Planes I* (Ill. 37), Léger's *Contrast of Forms* (Ill. 24) or Severini's *Shapes of a Dancer in Light* (Ill. 60), and to a certain extent also in Robert Delaunay's *Circular Shapes* (Ill. 29), Villon's *Troops on the March* (Ill. 33), Duchamp's *Nude Descending a Staircase, II* (Ill. 39), or Russolo's *Dynamics of an Automobile* (Ill. 64).

Kahnweiler describes the transition from an impressionism still indebted to the imitative concept of art, to the subsequent 'colour orgies' of the Fauves. Whereas Impressionism was concerned with the imitation of the external objective world in order to 'try to see art through nature', the colour orgies of the Fauves were a departure from imitation in order to 'put ourselves under the tutelage of art so that it can show us what nature really looks like' (Fiedler). According to Kahnweiler, this brings with it both freedom and license, so that avant-garde artists have to find a new criterion for the unity of the work of art.

Yet, painting is free from practical demands; for instance, it does not help you as a map might to find your way across an ocean, but it is free to choose its objects. Western painters became aware of this truth relatively early. But that painting is also free to choose the means by which it portrays what it

8

chooses to portray, was essentially a discovery of the first quarter of the twentieth century, and not least of Cubism. That is what Kahnweiler means when he speaks of the unity of the work of art as a 'self-sufficient object', and states that less must be said about an object in the external visible world than about the object represented in terms proper to painting, about which as much as possible should be said. As for the free choice of both the object and the means used to portray it, the route described by Kahnweiler is as follows:

A form of painting which discovers that, despite all representational demands, colours are in fact a matter of choice according to the requirements of the painting rather than the external world, was achieved by the Fauves and the Expressionists. The Symbolists stressed the fact that the interrelations of the objects portrayed are a matter of free choice for the artist; arbitrary composition and ambiguity became particularly obtrusive features of painting.[4]

The momentous discovery of the independence of the means of painting from the demands of imitation, which had seemed until then the obvious task of painting, led by way of Cubism, Futurism and Expressionism to concrete or abstract art. Contemporary art historians disagree about who painted the first abstractions: Kandinsky in 1910 or Kupka.

Until the modern period it was taken for granted that an essential criterion for the unity of the work of art was that the picture should accord with a slice of the external world. The artistic avant-garde of the first decade of the twentieth century saw it as their mission not to perpetuate but to destroy such notions of unity. Artists were concerned, often with shocking directness, to make clear in their paintings that the visible world exists on one level and a representation of it, or something referring to it, exists on a quite different level. In this sense Kahnweiler is quite right to refer to the object *represented*, since in the late phase of Fauvism painting had already developed to a point where it was able to show, for instance, that a woman in a painting is never a woman, just as an eye in a painting can never be used to see with. In other words: a representation of a slice of the visible external world is never the repetition of that slice of reality, because an exact reproduction of that kind can only be made available in the original medium of the object itself. The notion of making a pure replica of that kind is, at least from an artistic viewpoint, absurd. In a book on twentieth-century art, the critic Carl Einstein even spoke in this regard of 'imitative insanity'.

After these preliminary definitions and distinctions which are intended to help the observer understand Cubist paintings, it is important to know what freely-chosen elements and forms Cubism uses, what possibilities of using and commenting on the represented object are opened up in that way, and to what aspects of these same objects Cubism in fact refers. In this regard, the most important pictures in this book are, in addition to Picasso's *Torero*, his *Nude in a Forest* (III. 7), Braque's *Houses at L'Estaque* (III. 12) and *Woman in an Armchair* (III. 13) and, for Futurism, Boccioni's *The Noise of the Street Reaches into the House* (III. 53) and Carrà's *The Red Horseman* (III. 57).

Artificial versus natural beauty

In 1908 Picasso was painting in Paris, during the summer mainly in the Rue-de-Bois in the Île-de-France. That year he produced, in addition to landscapes and still lifes, the figurative work *Family of Harlequins* (III. 6) and the vertical oil *Nude in a Forest* (III. 7). This work, which is now in the Leningrad Hermitage, shows a human figure which takes up almost the entire area of the canvas. In the upper half of the picture, to the right and to the left of the figure, and partly above it, there are tree-trunks with forked branches. The figure is a frontal view of a female nude in a slightly crouching position with

9

thighs straddled. The left arm rests on the left thigh and the hand opens upwards; the hand of the right arm is closed and held close to the body. The head is slightly inclined to the left side. The light is directed diagonally to the tree-trunks at top left above the thighs, trunk, shoulder, neck, and right-hand side of the face.

The foregoing description, which is concerned primarily with the choice and composition of the theme and could therefore apply to nudes of various periods in western painting, is obviously inadequate if we want to know how Picasso's work differs from the traditional representation of a nude. Picasso in his *Nude in a Forest* is not interested in nude painting in the style of, say, Renoir. There is no grace of pose or attitude; there is no delicate, sensitive depiction of flesh and no soft line visible through a light which brings out the rounded contours of the female body. There are no lovingly-drawn lines and no details which prompt the observer to imagine, say, a young girl, a mature woman or anything in any way erotic.

Even if we try to describe the nude in this painting more exactly in terms proper to conventional everyday perception, it is hard to think of it as anything other than gross, heavy, awkward and ungainly, and of the figure's position as clumsy and stiff, if not just unnatural. The limbs are almost dislocated, and one might easily suspect that the artist used a wooden lay-figure, of the kind found in some studios instead of live models, in order to study movement and proportion, and made it the subject matter of his painting. The outlines of the figure are hard, angular, broken, sharp-edged, and contrast strongly with the few visible curves. Proportion hardly plays any part in the picture, as is evident from more than just the gigantic feet. Instead of flesh we can speak at most of body colours, which are predominantly yellow, ochre, brown and, here and there, blue-green. The title, *Nude in a Forest (Large Dryad)* contrasts singularly with this impression. It suggests an ethereal, weightless creature. In Greek mythology dryads are tree-nymphs who, in traditional literature and painting, are represented as young girls under trees, singing, swaying and dancing. Picasso's dryad on the other hand is notable for her heaviness, compactness and sheer mass. The position of the legs and feet might at most suggest readiness to dance in the broadest sense.

An observer of Picasso's paintings who comes to the same results or similar conclusions as the foregoing, is more or less non-plussed as far as the meaning of the picture goes.

It also seems impossible to view this particular nude as merely an odd variant on the traditional norms of western painting governing the pictorial representation of the naked human body. Even if the conventional norms are relaxed somewhat, it is difficult to take the picture seriously, since it does not use proper means, or seems to understand them solely as provocation, in order to offer a rude rebuff to all normal visual expectations. At most we could say that the painter wished to give the public his interpretation of woman as the epitome of all that is ugly.

The observer is faced with similar problems when he tries to understand the famous painting *Grande Nue (Large Female Nude)* by Georges Braque (co-founder with Picasso of Cubism). This picture was also painted in 1908. Both works, Picasso's more emphatically than Braque's, have an undeniable effect on the spectator, which is certainly due to the autonomy and equilibrium of the composition. Initially, perhaps, this effect is sensed only as the immediate visual impact of the picture as such, without any further definition.

In what must be one of the earliest statements about Cubism, made during an interview that probably took place in autumn or winter 1908 and in which he referred to his *Grande Nue*, Braque showed the possibility of an alternative approach to his own and therefore to Picasso's work: 'I couldn't portray a woman in all her natural loveliness. I haven't the skill. No one has. I must, therefore, create a new sort of beauty, the beauty that appears to me in terms of volume, of line, of mass, of

weight, and through that beauty interpret my subjective impression. Nature is a mere pretext for a decorative composition, plus sentiment. It suggests emotion, and I translate that emotion into art. I want to expose the Absolute, and not merely the factitious woman'.[6]

Braque's statement makes clear that the attempts to describe Cubist paintings we have offered up to now are inadequate to what the artist himself calls a new kind of beauty. Pictures like *Landscape near L'Estaque* (Ill. 10), *Houses at L'Estaque* (Ill. 12) and of course Picasso's *Nude in a Forest*, which we started with, aimed at finding a means of depicting a new kind of beauty. They gradually dispensed with all attempts at imitation, which hitherto had tried to impose a woman's beauty on the spectator: shape and development, hair-style, ornaments and clothes, look, movement, posture and so on. Instead of imitating these characteristics and features, the artist himself begins *subjectively* to work out pictorial elements and techniques in order to structure and organize the painting appropriately: that is, so that the object in question is represented but not imitated.

We shall now try to explain how the distinction between 'natural beauty' and 'beauty . . . in terms of volume, of line, of weight' is to be understood in Picasso's painting. In general the female nude is divided in accordance with its verbally apportioned components: head, neck, trunk, arms, hands, legs, feet. The trees depicted show the same overall classification: trunks, branches, twigs. If the observer looks for details to complete the portrayal, his expectation of the soft, curved female form is disappointed. In place of the expected detail Picasso offers planes and forms which are meaningful in terms of painting as such, but quite inappropriate and alien to the conventional notion of a nude. The artist's devices that so disturb the observer do not offend against the general classification already described; it is the details before all else that annoy. The conjuncture of light and dark planes and sharply broken lines, the alternate curves and angles, give rise to forms reminiscent of those proper to geometry and stereometry.

Inasmuch as the female nude obeys the rules of imitation only in the major features, imitation itself is no more than a tool in the service of the pictorial structure proper. In this way the artist is treating not merely the female nude as a theme for the painting, but also the very process of imitation itself which he used to depict that nude. At the same time he succeeds, in contrast to the imitative structure of the major features, in offering in the minor features an arrangement of quasi-geometrical (triangle, rectangle, rhombus) and near-stereometrical forms (cube, sphere, pyramid, cylinder), which obey rules that are not only proper but specific to this particular painting.

The appearance of two distinct types of procedure, following in the one case the rules of imitation, in the other those of autonomous painting, reveals a gulf between major and minor features. The technique of autonomous painting within the more detailed areas even at this date foretells the later disintegration of the object into formal parts subserving the structure of the picture and nothing else.

It was important not only for Cubism as a whole, but for later constructive, concrete, abstract art that the use of ideal objects such as a triangle, rectangle or sphere, pyramid or cylinder, within a painting, should not depend on the painter as an individual, but on impersonal rules. The variants and details that do depend on the individual painter clearly arise only at the point of composition and arrangement of the whole from the elements or objects derived from geometry and stereometry. A black circle or a black square on a white ground, as painted by Malevich (probably in 1913), is always a circle or square, whereas the banderilla pictured in Picasso's *The Torero or the Aficionado* is merely a symbol and not a banderilla that could be used in an actual bull-ring.

Once one learns to see the distinction between the nude functioning as a pictorial motif, the—usually—imitative structure of the objects depicted and the specific development of a painting as it is completed, as a discrepancy between fragments of the objective nude and the autonomous

picture, it is clear that the apparently appropriate term 'ungainly' does not apply to Picasso's painting. The imitative notion of painting has been used for a quite different idea of a picture, in which volume, line, mass and weight play the main part. Here Picasso took the first step (he could hardly do more in the first phase of a new trend in painting) towards the replacement of imitation with a form of creation specific to painting as such.

The painter chooses his motif with a clear end in view and this motif plays an important part throughout Cubist painting. The structural nature of pictorial creativity must come to the fore, and therefore Cubist painters select simple objects from everyday life, such as jugs, vases, bottles, bowls and so on, as in Braque's *Still Life with Coffee Jug* (Ill. 11), Gris' *Eggs* (Ill. 17), *Bowl of Fruit and Carafe* (Ill. 19), Derain's *Still Life on a Table* (Ill. 38); musical instruments such as violins and guitars, as in Picasso's *The Violin* (Ill. 9), Braque's *Still Life with Guitar* (Ill. 15), and generally isolated figures, as in Braque's *Woman Reading* (Ill. 13), or his *Grande Nue* (1908); other relevant paintings are Gris' *Clown* (Ill. 21), La Fresnaye's *Man Sitting* (Ill. 34), Metzinger's *Woman with Guitar* (Ill. 41) and Malevich's *The Woodcutter* (Ill. 43).

Its position in front of a background enables the figure in Picasso's *Nude in a Forest* to suggest additional semi-geometrical forms with its limbs and their posture: for instance, the areas between arms and trunk, between legs and feet, but also between the nude figure and the trees, and of course between the figure and the edge of the picture. Here use is made of the simple optical fact that angular and straight shapes not only indicate straight forms but have a further angular relation to the background. The delimitation of quasi-geometrical forms becomes as much a motif of the picture as the pictorial or planar use of the figure. The interrelation of figure and ground makes them especially dependent on one another, but the distinction between figure and ground is never reduced or cancelled, as in Art Nouveau.

The techniques used to modify and replace the traditional figure-ground relation in the early phase of Cubism are especially clear in Braque's *Houses at L'Estaque* (Ill. 12). Equally good examples are, however, Picasso's *Houses on a Hillside* of 1909 and Léger's *The Bridge* of 1909. In his landscape Braque arranges the stylized houses as naked, angular masses in layers from bottom right to top left until they reach the borders of the picture, so that there is no real background for the figurative element. The structure Braque has chosen, the view from above, makes possible this close piling up of the Cubist shapes with coloured cross-hatching to emphasize the directions of lines and angles. The stylized tree on the left determines the overall direction of the mass of houses. In this case it is pointless to talk of anything like a landscape background in the normal sense. This is also true of Braque's *Landscape near L'Estaque* (Ill. 10), and Gleizes's *Landscape at Montreuil* (Ill. 40).

The reduction of the colour scale to a few tones distributed over the entire picture is tantamount to a rejection of the use of specific individual colours for the objects depicted, and extends from the absence of local colour to an increasingly uniform overall tonality in the painting and to equal treatment of the plane surfaces. In this way all parts of the picture become components of equal value. In Picasso's work during this early phase of the development of Cubism, this tendency leads to a strong approximation of figure to ground, and in Braque's *Houses at L'Estaque* even to the cancellation of the figure-ground relation.

The representation of objects and the organization of the picture as a whole obey the criterion of simplicity, first in regard to the choice of motif, and second in regard to the forms. Instead of differentiation and detailed treatment of the objects, the major distinctions are accentuated. The colour treatment is also geared to simplicity. The use of colours suited to the objects in the external world is separated from the function of colour as a means primarily of distinguishing one form from

another and hence above all of subserving representation. The phenomenologist W. Schapp says: 'colour is only that which sets a limit to vision and in that way makes the body visible at all. Accordingly colour plays, so to speak, the same rôle as a colorant in biology. In the latter case, too, the researcher dyes the colourless cells and nuclei so that he can see them under the microscope, in order to produce a resistance for the eye'.[7] The use of colour to achieve this resistance and thus aid vision is apparent not only in Picasso's *Nude in a Forest* but in his *Family of Harlequins* (Ill. 6), Braque's *Still Life with Coffee Jug* (Ill. 11) and Gris' *Eggs* (Ill. 17).

Precisely because the pictures obey the rule of simplicity and thus contribute to the maintenance of order within the whole, they enable the spectator to distinguish part-forms and part-objects which stand out against the similarity of the objects shown. Gris especially developed the technique of stressing similarity as a major feature of his painting, as can already be seen in his early work, for instance in *Eggs* (Ill. 17, see also the text for Ill. 17–22).

Early Cubism: the use of basic non-representational forms

We know from pictures painted in the traditional way that artists choose specific pictorial means in order to portray, say, a woman mimetically, i.e. imitatively, and call upon them in accordance with the demands of the particular theme. Among such means are lines, outlines, shapes, patches of colour, colour tones, and so on. A painter who works imitatively with such means uses them primarily in order to refer to objects which exist outside the framework of his painting. Such external objects can also be other paintings, which are often found as motifs in interiors by Dutch and Flemish painters of the seventeenth century.

When a painter, as he practises his art, realizes that the pictorial means are also a matter of free choice, he is close to the realization not only that he can use these means not as mere imitation of, say, a woman, but also that he can treat those very means as objects in their own right. Through his own creative invention and experience, he can use the means to produce artistic complexes which exist only as and in painting. In this sense it is possible to say that the painter is no longer interested in portraying a woman but in discovering and 'realizing' pictorially autonomous elements and constructions. 'Realization' in this sense was *the* watchword of the Cubists; it had, of course, already been very important in Cézanne's work.[8]

The use of the pictorial means as an object together with or like any other semiotic means is familiar to all of us in our recourse to natural language. We can always, for example, use the word 'Edinburgh' to refer to the capital of Scotland. But we can also say something about the word 'Edinburgh' itself; for instance: 'The word "Edinburgh" has more than four letters in it but less than four syllables'. When statements are made with words, we say that the words are being *used*. If, however, we merely speak *about* words, they are only cited or *quoted*, in such a way that they themselves become the object of discourse. In order to make clear that we can use verbal means to talk *about* verbal means, a distinction is made between the language about which we speak, i.e., language at an objective level, and language with which we speak, i.e., language at a meta-level. Levels can be extended if necessary to become meta-meta-levels, and so on. To show that we are speaking about verbal means, nowadays we usually place the words discussed in quotation marks.

We can spell words, count their syllables, describe the rules for their formation and decide to which natural language they belong. Similarly with pictorial and, in our case, painterly means. The experimental painters of the early years of this century taught us to see that this was possible, and how very

possible it was. In Cubism, Futurism and Expressionism the painter begins by turning the artistic means themselves, the use of which is made possible by painting itself, into the object of that very painting. A. Hölzel put it in this way: 'I can twist and turn it how I will: art is in the means'. 'Absolute art is that form of art in which the powers and qualities of the artistic means take effect with the least possible external influence'.[9] The Russian painter Wassily Kandinsky, whose work descended from the initial products of Art Nouveau and German Expressionism, put this decisive reformulation of artistic practice most appropriately in his now-famous article of 1912, *On the Question of Form*: 'The line . . . is a thing, which has a practical and purposeful aspect just as much as a chair, a fountain, a knife, a book and so forth. And this thing . . . is used as a pure painterly instrument, without reference to the other aspects which it might also possess; it is used, therefore, in its pure inward resonance'.[10]

We must now use the foregoing conclusions to answer what is certainly not a simple question: that of how the change took place from imitative or pure representational painting (which in the mid-nineteenth century was as absolutely binding on painters as on patrons and recipients) to the artistic techniques whose intention is to make the means proper to painting quite exclusively the proper objects of painting. Here all we can do is to give a summary account of the process of change, without unfortunately even a short history of the development of the conditions for such change, which go back deep into the nineteenth century (for instance, in the field of colour and perception theory, where the specificity and autonomy of vision were stressed increasingly). Picasso's painting *Nude in a Forest* is very suitable for a summary account of this question too. We saw how in Picasso's picture, in addition to the pictorial element, other elements come into play which no longer accord with imitative representation as such. Although the female figure roughly fits the still effective naturalistic intention and can therefore still be recognized, the painter is no longer trying to fulfil the spectator's expectation and to present the beauty of the naked female body as a configuration resulting from an imitative act of painting. Instead he draws attention to forms which are specific to the painting yet alien to the process of imitation. These forms which can no longer be reconciled with the process of imitative painting may be characterized as basic Cubist forms or elements on account of their closeness to geometric and stereometric forms; but they are properly Cubist only when they cannot be reduced or simplified any further (except when an artist decides to simplify his picture by gradually reducing forms, to such an extent, that he finally achieves the uniformity of a totally monochrome canvas. At first the Cubists did not alter the canon of material requisites for painting: support (wood, canvas, cardboard), priming, colour (pigment) and medium.

If the basic Cubist elements are applied on an imitative basis, but do not determine the structure of the picture and do not follow rules of organization specific to the painting as such, they are not *used* but merely *introduced*, or cited. In other words, under the title of what has been known hitherto as nude painting, these Cubist means are portrayed, explored, assessed or—metaphorically—optically presented for discussion. This introduction of Cubist means in an objective and thematic 'form' may be observed in Picasso's *Les Demoiselles d'Avignon* (III. 4), Braque's *Still Life with Coffee Jug* (III. 13), Derain's *Still Life on a Table* (III. 38) and Malevich's *The Woodcutter* (III. 43), quite independently of the particular theme of the pictures and their historical origin. If we look at it thus, the conventional form of representation is an aid to the use of the new objects of painting.

The conventional means of imitative painting are used to introduce new means. In this kind of art the imitative element helps present the fundamental means to the spectator, just as an ABC book instructs the child on how to write individual letters and words without using them for specific written messages.

The examples above show that, whereas imitative representation merely mimics what we already perceive in one particular way, by introducing the basic elements of Cubism these paintings accentuate the artist's concern with the creation of something new in the medium of painting itself. Artistic creation is seen as a specific activity which itself makes and produces something that did not exist before this process of making and producing. It is part of the radical commitment of this self-production thoroughly to explore and develop the artistic means proper to the medium of painting. Here it is permissible to speak of the 'realism of the medium', for the painter starts from the very beginning. Cubism followed this basic rule in a most exemplary manner in its initial phase, when the elements of Cubism were developed and presented as a fundamental 'vocabulary' on an imitative basis. Because of its quasi-geometrical forms, most familiar to us from stereometry, this 'vocabulary' is optically accessible and directly identifiable. This enables an artist to direct the observation of the picture on the basis of a known vocabulary of forms, without making any further provisions for understanding. If we study, for example, *Nude in a Forest* for some time, the usual process may be reversed and we begin to see the nude by means of the 'secondary' Cubist detail instead of by means of the grosser imitative elements.

Any verbal statements by painters in this period are extremely rare, since they were fully absorbed by the practical problems of introducing a complete repertoire of Cubist techniques into painting. Picasso said at the beginning of the 'Twenties: 'When we "invented" Cubism, we did not intend to invent it. We were only trying to express what was in us. None of us had drawn up any special plan of campaign, and even though our writer friends followed our activities with the greatest interest, they did not lay down any programme for us to follow'.[11]

Our everyday use of natural language tells us that we need more than a vocabulary to be understood. A child who, in the first year at primary school has learned how to write a few words, phrases and even short sentences, is not yet able to write a holiday letter. In other words, an essential part of a language is the knowledge of how to combine the acquired elements in larger units, how to arrange and structure them, and how to produce compound sentences and even complete texts from simple sentences. The Cubist pictures we have given as examples do not help us in this respect. If we only know works from this early phase of Cubism, we are unaware that these artists succeeded in turning their basic pictorial elements into a pictorial language by renouncing imitative representation, and that the basic elements are to be used autonomously to structure and organize a picture. When the evolved vocabulary is only introduced or 'quoted', it is necessarily subservient to the imitative structure, so that there is hardly anything to be made of it beyond its pictorially specific, and, in that sense, constructive organization. The basic vocabulary of Cubism, as used by Picasso in the early work we have cited hitherto, is introduced only from the standpoint of imitation. Even in Braque's *Landscape near L'Estaque* (Ill. 12), Cubist elements are used exclusively to portray a piece of countryside. Hence, for instance, the following difficulty: in the representation, imitative forms are often used quite inappropriately and are partly or wholly identical with the forms in the final work intended by the artist. The result, as our preliminary remarks indicated, is that an impression of ungainliness and imprecision cannot be excluded. On the other hand, and this is much more to the point, the spectator is able to see how it is artistically possible to use signs in a specifically painterly way in order to refer to objects in the external world, without in any way representing them imitatively.

So long as the basic Cubist elements are merely introduced on an imitative basis, so that the observer is able to participate directly in the formation and development of the autonomous means of painting, we should speak of *early Cubism*. The advantage of this is that we do not see early Cubism

merely as a specific historical period, say, between 1907 and 1909, which is essentially restricted to the development of the work of Braque and Picasso. Instead we can also discern a period in the evolution of a number of painters which can vary considerably from the mere historical progression of early Cubism. An individual might well revert to this phase in his later work, or never succeed in progressing beyond it. Many artists, as the illustrations show, were disciples of Picasso and Braque and adopted the basic vocabulary of Cubist forms those two artists constantly developed; but being under the impression that it was easily assimilable, they never truly integrated it into their own painting. Early on Carl Einstein objected to all those who used Cubist techniques 'sentimentally', in order merely to maunder along without revolutionizing their work. Others of course underwent a transformation and worked out new perspectives; Robert Delaunay, for example (Ill. 27–29) used not volume but colour to construct and organize his paintings.

In a painter's work, the phase of early Cubism ends where he abandons the tendency to imitate and follows original rules of organization in his application and arrangement of the existing Cubist vocabulary. Artistic inventions have never been wanting in western painting. Otherwise development in this field would be inconceivable. But, essentially, these inventions have always operated within a framework of objective representations.

In Cubism, however, invention went beyond this framework by concentrating on it. Early Cubism showed how to conceive and produce the basic forms of a pictorially inherent visual language. The pictorially autonomous rules, to which the basic Cubist vocabulary is subject when it is itself *used* to produce and construct a painting, became fully apparent only in the second stage of Cubism: analytical Cubism. Early Cubism helps us to understand what 'analysis' or 'dissection' really meant in this second phase. The introduction of Cubist elements into the secondary detail of a motif is an indication that the technique is being used to analyse the object 'depicted' into Cubist forms appropriate to the construction of the painting.

When speaking about analytical Cubism, it is also important to keep it distinct from Futurist conceptions, something that artistic programmes and manifestos tend not to do. Nevertheless the various pronouncements and manifestos are very closely bound up with the process of artistic development. How important the actual reflections of the Futurists are for the understanding of their paintings is also stressed in the notes on the individual works.

Analytical Cubism: the self-sufficient image

After the foregoing remarks, we return to Picasso's *Torero* (Ill. 8) and Braque's *Woman Reading (Woman in an Armchair)* (Ill. 13). Here something should strike us immediately: the individual parts of these pictures so approximate one another that there is little point in continuing to talk about major and minor structures. Both paintings offer a more or less uniform structuration of the entire pictorial field. The impression of a largely closed view is considerably emphasized by uniform coloration. This sense of closure is further accentuated by the use of the total surface as an 'overall reference surface' (T. Lenk) for forms and colours alike, because the painter thinks of the two-dimensional surface as the sole determinative factor in the process of painting. The objective themes announced in the titles of both paintings are clearly subordinate to the pictorial configuration on the canvas. Carl Einstein rightly says that the objective element in such paintings is sacrificed to the 'pictorial body'.[13] This tendency is taken so far (as can more clearly be seen in the Braque painting), that the Cubist organizations of

volumes are seen as primarily surface phenomena. The two-dimensional painted surface has a certain transparency which allows the eye, as it were, to penetrate to some extent into the structure of volumes on the surface—rather like looking into cloudy water. This transparency is enhanced by peculiar clear spots which extend to dull or smooth areas and look as if someone had tried to wipe them clean. They also look as if they were giving off a reflection.

Yet all these points, however important individually, do not help the observer with the answer to the nagging question of what the titles have to do with the paintings themselves.

We have seen how in early Cubism the main subject of inspiration remains intact, whereas the Cubist forms appear in the secondary detail. Therefore, it is not difficult, for instance to recognize a coffee jug in Braque's *Still life with Coffee Jug* (Ill. 11). This is also true of Picasso's *Family of Harlequins* (Ill. 6). We can only speak of analytical Cubism when there is no longer any essential difference of approach; when the principle of imitation is not used as a basis for structuring Cubist forms, and no clues are given to those who still want to look at the picture in a conventional way. The Cubist elements and forms are distributed over the entire surface of the painting, which they un-equivocally determine; while in the case of early Cubism it was reasonable to ask where the Cubist forms were, the opposite is now true. The observer is now inclined, in fact required by the picture, to hunt for imitative details. The more the Cubist painter renounces imitation in his Cubist configura-tions, the more difficult it is for the observer to make something of a Cubist painting if he still relies on ordinary everyday language. At this stage he can rely only on the painting and has to begin afresh with each new picture. He can only understand these pictures, such as our two examples and others belonging to analytical Cubism, if he accepts composition, structure, order and an arrangement specifically orientated to the painting itself and to the spectator.

The first indication of the transformed, in fact wholly novel arrangement of pictorial elements and forms, is provided by the fact that the format of the picture has become one of its essential elements. Picasso's *Torero* and Braque's *Woman Reading* are vertical paintings. If one's eyes consciously follow the directions of forms, lines and angles, one realizes that they all point to the vertical: hence the vertical format. Horizontal components tend to stabilize the vertical structure and do not disturb or oppose it. The diagonals also tend to rise and support the general vertical tendency.

The structure and arrangement of analytical Cubist paintings will become apparent when we ask what exactly is analytical in them. Another closely-connected question is that of how the Cubist painter who has surrendered the concept of imitation can ensure the optical unity of his paintings. Early Cubism was primarily and initially concerned with the development and presentation of Cubist forms within the imitative element of the painting. In the analytical phase this repertoire of forms was no longer introduced or cited but *used* to classify the objective and thematic content, to break it down and analyse it. In terms of painting, this process of analysis has to fulfil three tasks: it must allow the object to appear in pieces and fragments, for instance, parts of a face, a bull, a head-dress or a chair, a book, and so forth. The fragmentation should also enable the object to be seen from various viewpoints and in different uses and approaches, above all in regard to sight, touch, and so on. Braque explained that he always wanted 'not just to see but to hold things'.[14] When confronted even by early Cubist pictures, the spectator should explore them as if he could actually touch the objects. The observer of *Still Life with Coffee Jug* (Ill. 11) sees the coffee jug and the other jug from the front, but can also look into the open top of the jug and is tempted, as it were, to put his hand inside. The same is true of Derain's *Still Life on a Table* (Ill. 38). The analytical Cubist structure of Picasso's *Torero* and Braque's *Woman Reading* tempts one to feel them with the same intensity with which one scrutinizes them. The Cubist fragments are broken down in such a way that they actually stabilize the picture.

People often say that Cubist pictures show several different views of objects as seen from the outside world. This is quite wrong, for the pictures increasingly obfuscate exact details of viewpoint, in order to assert their painterly autonomy all the more emphatically. If one relies on the picture itself, there is hardly any way in which one can distinguish the standpoints from which the supposed multiplicity of views is obtained. Only in very rare cases are the viewpoints in the picture really comparable in that sense. All talk of different views, which derives from the practice of early Cubism, tacitly demands an imitative representation in the painting, and suggests that it is the prime duty of the spectator to combine the objectively identifiable parts and fragments into a naturalistic concept antecedent to the picture, and to compare that concept with the finished painting. Analytical Cubism in particular is an excellent example of the futility of assuming a purely inward process of awareness or thought which then becomes the outward painterly interpretation of objects which at one time formed a unity. Instead, all artistic activity is in the painting and occurs only at the same time as the painting. That means that the conception, arrangement and application of the means of painting are so combined in the picture that a description of these means as artistic tools also describes their application. This form of painting tries to ensure that the totality of available means decides the terms on which their arrangement and application are to be seen by constantly insisting on this simultaneity. In other words, the painter 'organizing' the theme *Piano and Mandolin*, a Braque painting of 1909–10,[15] has no set of instructions telling him, as it were, to remove a fragment of key from the piano, to wipe out the hole in the mandolin, and so on; instead the final appearance of the painting comes into being only as pictorial entity. These works do not start from a predetermined plan, but discover their plan for the first time in the actual realization of the picture. Accordingly, it is almost impossible to say anything definitive about these paintings unless they are in front of one. To take another example: the paintings of analytical Cubism, in which the developed basic vocabulary of Cubism is applied without any imitative devices in accordance with rules which support each specific structure, are not designed like puzzles. When painting, the artist uses no parts decided in advance and no rules of composition. There is no schema or scenario which the artist follows in constructing the picture and which he can use to test what he has done to see if it needs correction. Instead the very process of painting throws up individual formations and arrangements, with geometrical and stereometrical analogies, which have to be tested for pictorially structural adequacy. This is the reason why any experiment in cutting up colour reproductions of the *Torero* or *Woman Reading* in order to reduce them to their individual parts is doomed to failure.

We learned the vocabulary of early Cubism with the aid of imitative painting. We can speak of a Cubist pictorial language only when it has its own specific laws of organization. This is always the case in analytical Cubism, where imitation disappears in favour of a Cubist principle of order. In Picasso's *Torero* we have a configuration of sharp-edged and angled forms which are relatively isolated yet also elements of the same multi-faceted tracery. In general these forms have a vertical format. The arrangement and interrelation of the individual forms, segments and parts are always subject to the introduction of spatial and planar ambiguity. For example, the planes are so interrelated that spatial distances are observable but isolated, so that they do not give the whole picture a uniform spatiality. The angular forms are equally ambiguous as regards their superficial linear value. They serve to delimit and to separate planes, but are also used to intersect and to fill part-fields. These aspects enable us to look at the pictorial elements from different points and virtually to interconnect them. In addition, therefore, to the artificial ambiguity of the composition, there is a fictive network which is absent from the picture as such and appears only in the process of contemplation.

In analytical Cubism, then, the painter does not analyse objects, before he starts painting, only to

depict those fragments. Analysis, division and arrangement take place in the act of painting so as to produce an orderly whole. In the picture, breakdown or analysis are visible only in coordination and structuration.

The complex fact determines whether the painter can smoothly insert realistically painted details, such as a banderilla, into a picture in the same way as the word '*Nimes*' and other letters and words. The ambiguous structure of the painting makes possible a multilateral connection of these and all other pictorial elements.

We may say, then, that the ideal student of a Cubist work of art must be absolutely prepared to trust the paintings themselves. Such an observer will obtain sensuous satisfaction and pleasure in an openness and an adventurous perception that depend on the actual characteristics of the paintings rather than some predetermined formula of assessment. Cubist art is fully achieved when a picture affords perfect equilibrium between direct visual apprehension, knowledge and memory. The observer has to apply all his sensitivity and responsiveness in maintaining the balance between the obvious and the incomprehensible.

Futurist painting as 'transitional' art

Early Cubism is best regarded as a search for forms and elements which would contribute to the stability of the painting; thus it developed a repertoire of basic pictorial elements analogous to ideal objects in geometry and stereometry. It also disregards objective and thematic representation to focus on an ordered pictorial structure which is intended to afford the best possible perception of the object represented: for example, by requiring the use of touch as well as vision.

Like the Expressionists,[16] the Futurist painters rejected the heritage of western art and culture, in order to move as freely as possible without the burden of tradition towards new formal discoveries, which always included new ways of living. Boccioni formulated their problematic initial situation thus: 'Futurist painting is in an especially difficult position. It arose in Italy and therefore developed in a country without any modern art tradition—a country which is in fact blind to modern art. In this respect Italy is thought of abroad as the Boeotia of Europe'.[17] Only from this standpoint can we understand the programmatic, anti-traditional element in the *Manifesto of Futurist Painters* of 1910: 'We want to struggle unremittingly against the fanatical, irresponsible and snobbish cult of the past, which depends on the unhealthy existence of museums. We are against blind worship of old paintings, old statues and all old objects, and against enthusiasm for everything that is wormeaten, grubby and consumed by time; and we find the usual contempt for everything young, new and lively, unjust and criminal'.[18]

Although these artists were concerned to find and recommend a conception of life appropriate to the great progress that had been made in science and technology, the Futurist movement in art was not a social movement with any noticeable large-scale effects. 'Our paintings are Futurist', says Boccioni in his foreword to the catalogue of the Futurist exhibitions of 1912, 'because they are the results of ethical, aesthetic, political and social ideas which are wholly futuristic'.[19]

From representation to the depiction of movement

Just as strongly, perhaps even more strongly than with early Cubism, the observer of Futurist paint-
ings is faced with the question: 'What does the artist intend? What does he want to communicate?' In
Carrà's *The Red Horseman* (Ill. 57) the horse and rider can be fairly clearly made out. The rider is
leaning forwards over the horse's neck. It is easy to discern, for instance, his somewhat too large (in
relation to his body), naked leg on which you can see the individual toes. To this extent the portrayal is
somewhat imitative. Yet, in comparison with Picasso's *Nude in a Forest* (Ill. 7) it is much more difficult
to talk of major and minor structures, of coarse and detailed parts of the painting, for the horse and
rider as a whole are relatively 'disfigured'. Both are not, as is usual, described by means of a consistent
and continuous outline. The delimitation of the animal and human bodies is variable, and there are
certain repetitions and superimpositions. Once the observer notices this, his eye is almost unwillingly
drawn to the horse's legs which are repeated and shown in a partly obscured, entangled form.

Ray-shaped diagonals directed to the edges of the picture are also evident, and it eventually
becomes clear that the intention is that the observer should be enabled to see neither a horse standing
still, nor a horse galloping but a horse 'undergoing' the whole process or activity of galloping. The
artist does not wish to show a typical moment in galloping. He wants to visualize the process of
galloping. The devices by which horse and rider are shown are the opposite of imitation. Galloping is
not arrested and shown (as is conventional) as one particular gallop. Instead the whole action is
depicted.

In addition to this method of representing motion, by which the figure as a whole is retained but its
limbs are multiplied to indicate movement, Futurism developed a second technique which we shall
describe from Balla's oil *Child Running along the Balcony* (Ill. 48). Here the eye is directed initially to a
relatively unified and in fact uniform arrangement of large *taches* of colour through which it is possible
to distinguish shapes which are repeatedly differentiated from head to legs and feet, so that the eye
finally begins to follow a series of feet across the picture. The title shows conclusively that the picture
does not depict five to seven different figures running from left to right, but a single figure which is
shown at various points on the picture, in order to reproduce, in a way suited to the surface of a
canvas, the continuous movement of running along a balcony. The observer has to perceive the
various stages in the representation of one and the same figure (and not several figures at once) as
representing its chronological movement, or the process of movement in time (see text on Balla, Ill.
48–50). Baumeister's remark is relevant in this context: 'Time cannot be measured but only divided
superficially'.[20] This method of dividing movement into phases should be compared with chrono-
photography as developed by Marey and Muybridge, though the comparison offers no sufficient crite-
rion of assessment for Balla's method of painting. The photodynamics of A. G. Bragaglia, which date
from 1910 and with which he recorded the visible aspect and course of a movement, are equally
important for the pictorial representation of motion. Bragaglia's *Futuristic Photodynamics*
(*Fotodinamismo Futurista*)[21] was published in 1911.

Boccioni's *The Noise of the Street Reaches into the House* (Ill. 53) is a good example of the course
Futurism was to take subsequently. (Close analysis of Futurist techniques is offered in the com-
mentary on the illustrations).

Boccioni uses the spectator-figure in the foreground to direct the observer's eye to the centre of the
picture. There the organization of the painting draws the eye into a coloured whirl of diverse objects.
This confusion becomes particularly unstable at the edges of the composition; it is as if the objective
content were somehow suppressed at the edges or, rather, fading from the world of the picture.

Meidner, a Berlin Expressionist, tried to use exactly the same technique for quite different purposes. He was not so interested as Boccioni in the visual rendering of movement, but wanted, for instance, to introduce an apocalyptic note and a sense of rupture and downfall into his townscapes.[22] Boccioni's further development of the process is shown in the predominant circularity of the *Dynamics of a Footballer* (III. 54; cf. Russolo, III. 62, 63). Here the artist develops his motif and constructs his picture so that the observer himself becomes part of a dynamic pictorial process.

All three methods of pictorial representation of movement try to make the observer abandon his remoteness and become a participant through direct visual involvement. The composition in these instances persuades the observer's eye to follow every declivity and fragmentation of the object as depicted on the canvas, moving straight ahead or in circles as directed. The painter does not construct the picture so that the observer can take the whole thing in one visual sweep, nor does he allow the moving or moved objects just to pass by his resting eye, as happens in Duchamp's *Nude Descending a Staircase, II* (see the text for III. 39).

As shown in our examples, the Futurist painters dedicated themselves to movement, a theme which had been especially neglected in the static medium of painting, or had been thought of as inappropriate. They conceived movement as a sequence of phases of action, and depicted change as change of location, impetus and advance, or tempo: in short, as dynamics. They were not interested in 'possible points of contact' (as Boccioni put it) with classical art and aesthetics. To understand the goal of this method more effectively, we must remember the 'Laocöon problem'. In his famous work *Laocöon, or on the Bounds of Painting and Poetry* (1766), Gottfried Lessing put forward the thesis of the distinctive approaches proper to plastic art and literature; he defined poetry as a chronological sequence and painting as a spatial series. As Goethe's friend H. Meyer and Goethe himself later deduced, Lessing attacked the problem of the pictorial representation of a chronologically or spatially sequential action with the proposal that the sequence of movement in a specific action should be portrayed at its particular point of culmination, or 'fruitful moment', so that the spectator might deduce from it what had gone before and what was to follow. When one contemplates what is portrayed as an individual moment, one should see the totality of the action which is merely suggested by the movement of bodies. The idea that an action should be defined in its 'pregnant moment' was of course put forward by Lessing only within the framework and on the basis of an imitative representation.

The Futurists proceeded differently. Both in their early work, for instance Balla in *Rhythm of Movement of a Dog on a Lead*, III. 48–50, or Carrà in *The Red Horseman*, in which they use vague multiplication of limbs to show movement, and in their later work influenced by 'chronophotography', the Futurists rejected Lessing's suggestion that one aspect, or moment, of movement should be shown as a culmination of an entire action. They wanted to avoid the kind of pose appropriate to the stage by putting the same figure (for instance, the child in Balla's *A Child Runs Along the Balcony*) in several distinct positions and the apposite phases of body movement. Of course, this way of presenting the figure (and here there is a connexion with early Cubism) fits the imitative notion of painting. The repetition in paint of those parts of the body which stand for movement, and the fragmentation of individual figures into postures and phases occur in accordance with criteria which are certainly specific to the painting yet refer to the 'objective' theme, even though they go beyond a strictly imitative representation. Henceforth the pictures demand a spectator who is prepared to think twice about concentrating on an imitation. This particular separation of objective from figurative elements does not use quasi-geometrical or stereometrical forms, but accords entirely with the spontaneity and intuition demanded by the Futurists. It is concerned with the main theme of Futurism: movement,

speed and tempo in a two-dimensional painting. The technique of the French Divisionists, who used colour in a loose sequence of uniformly applied patches, was heightened by the Futurists in order to fit their dissection of form. Its new task was not the establishment of a visually arousing colour perspective but the portrayal of the transient nature of movement. In Balla's *A Child Runs along the Balcony*, the larger blobs of colour similar to those favoured by Divisionism became the 'energetic particles' of Futurism.

The goal was an abandonment of imitation in order to concentrate on the only themes of interest to the Futurists: rhythm, speed, dynamics; these had to be represented with pictorially autonomous means, or non-imitative visual signs. As a first step the Futurists developed linear components from the technique of essential breakdown or 'division', which dominated the composition. Here it was especially important not to use verticals and horizontals as visual guidelines and they were altogether dispensed with. According to Carrà, the right angle is mainly an 'expression of sublime rest and rejoicing'.[23] In place of horizontals and verticals the Futurists used round or curved shapes such as arcs, segments of spheres and spirals. These convolutions were countered effectively by acute angles whose acuity was emphasized by the length of the sides running diagonally across the picture. Twisted lines and obtuse angles occupied the intermediate area between these linear components. The French painter Robert Delaunay (Ill. 27–29) possibly thought of his colour method as a means of presenting simultaneously interacting colours and thus obtaining a form of 'pure visibility'. The Italian Futurists succeeded in obeying the rules of painting while showing the interaction and opposition of various forces of directions in apparently simultaneous movement. 'The acute angle' . . . said Carrà, 'is ardent, impetuous and dynamic. It expresses volition and persistence. The obtuse angle is the geometrical expression of the variability and neglect of that same will and power. The crooked or curving line has an intermediate function: it is a "transitional" form, and together with obtuse angles serves to unite the other angles'.[24] In order to portray this simultaneity, the Futurists constructed their pictures from precisely-described axes or guidelines, while gradually dispensing with the direct use of wheels, the hub of a car-wheel (cf. Balla, Ill. 49, 50), and arms and legs (cf. Boccioni, Ill. 52, 54, Severini, Ill. 60). Sharp colour contrasts are also evident: for instance, red and blue (cf. Russolo, Ill. 62, 64) without any intermediate colour.

The greater the emphasis on the non-objective, non-imitative way of depicting movement in art, the more obviously this was reflected in the titles of the paintings: *Dynamics of a Footballer* (Ill. 54), *Dynamic Hieroglyph of the Bal Tabarin* (Ill. 59), *Dynamics of an Automobile* (Ill. 64). Futurism was most precisely formulated when it combined simultaneously effective axes ('lines of force') and 'energetic' coloration so that the observer sees movement and nothing but movement.

Cubism and Futurism compared

It is undeniable that the Paris avant-garde at the time of Cubism influenced the course of Futurism. We can also trace the effects of Cubism and Futurism on German Expressionism. Yet as far as essentials went, Cubist and Futurist artists worked independently of one another in their use of division and analysis of conventional objective and thematic modes of representation in order to present the painting as a cohesive pictorial entity, or as an image of movement. The similarity of Cubist and Futurist techniques itself prompted a certain amount of interaction. This concerted attempt to fragment the objective world was evidently based on a new idea of what painting could and should 'show'. Nineteenth-century realism and then photography had made the perception of the *status quo*, of hard

facts, a representational norm. It was that norm that Cubists and Futurists set out to destroy. They thought art should respond quite differently to the objective components of the visible world. They were no longer interested in copying the images of the everyday world that people already knew only too well: for instance, street scenes or family and work situations. This conception of a work of art may be compared with the attitude of someone who drives a car not because he wants to experience any incidental sensations, but because he is primarily interested in getting to work on time. The desire to experience and to sense things is characteristic of a second type of perception: that which is concerned with testing, discriminating and recognizing objects, and their characteristics and qualities. This 'theoretical'[25] perception is the kind proper to a man who does not just saw a plank of wood, but who is primarily concerned in sawing to experience something of and about the hardness, softness and fibrous nature of wood as a material. Cubist and Futurist pictures are made exclusively for this second kind of perception. For that reason they are 'a-scenic' and do not represent any situation or complex of situations. We have already referred to this feature of Cubism when discussing Picasso's *The Torero or the Aficionado*.

The realistic form of representation, then, adheres to the conventional form of perception which is interested in practical things, in work; whereas the theoretical attitude to perception concentrates on the sensuous cognition of the characteristics, qualities and conditions of various objects. Hence Cubist and Futurist pictures no longer cite the objects portrayed so as to evoke empathy and direct identification, or as practical objects with a use-value, but introduce them only as objects comprehensible in terms of theoretical perception. Whereas realistic painting might be interested, for example, in portraying a young peasant working with good tools and ready strength, Cubism is interested in the lack of logical connexion between modes of perception: sight and touch, for instance. To the eyes a stick held under water seems crooked or broken, but touch shows that not to be so. This discrepancy was one that the Cubists tried to transcend optically by assembling a repertoire of forms specific to painting, and by the devices of autonomous arrangement and organization. In so doing they disclosed the laws governing our perception. Picasso's dilemma, whether 'things ought not to be painted as they are known rather than as they are seen',[26] is an understandable one. He touched on the probable starting-point of the tendency to fragment and analyse in Cubism and Futurism. Painters begin to undo the objective world when they find they can no longer take up a 'utility' attitude to objects and represent what they know from just looking at it. Instead, they want to show in one and the same picture what they actually know about the object and its environment: for example, that a violin also has a back, a jug an opening, and a motor car four wheels—only two of which are generally to be seen.[27] Cubism wishes to bring seeing and knowing together and to portray knowledge as if it were an object. Futurism, on the other hand, does not concentrate on the visual apprehension of a distinctive aspect of movement but, for example, on the scientifically grounded knowledge of how a movement takes place and is carried through.

If painting is conceived as the art of applying pigment to a two-dimensional surface, artistic aims of this order can be achieved only by analysing the objects in question. Futurist and Cubist painters, faced with an historically constituted influence, do not represent elements which depend on the object alone; they do not merely reveal the object in its 'existential aspect'. Instead they are interested in representing the 'common product of the object . . . of light, of the environment and of a changing viewpoint . . . as an effective form'.[28] Both Cubism and Futurism accept that painting is a static medium, but Cubism strongly emphasizes its static aspects, partly in order to establish patterns of mediation between planar stability and spatial instability, whereas Futurism is interested in exploring and revealing the energetic-dynamic possibilities of the pictorial area.

Futurism keeps up the association witn movement even when it has developed (through painting) adequate non-imitative means of representing dynamics. In its most extreme form, analytical Cubism still seemed to concentrate on the principle of painterly destruction and analysis. The absolute postulation of the fragmentation principle in the analytical phase led directly to the third phase: 'synthetic Cubism'. The central aim of synthetic pictures, such as Picasso's *Violin* (Ill. 9), Braque's *Still Life with Guitar* (Ill. 15) and Gris' *Still Life on a Table* (Ill. 20) is to combine references to the basic Cubist elements of the early phase with the independent analysis principle of the analytical phase, thus producing compositions which revert to an obvious form of objective reference. The importance of a unified picture was heavily stressed in the analytical phase, when theme and motif were no more than a starting-point and pretext for the specific composition. But now the Cubist vocabulary and analytical method themselves became the basis for a specifically pictorial arrangement of objective elements. In short, an essentially non-representational way of using pictorial means is a comment on imitation as a way of representing the visible world. It was in this context that the Cubists, in particular Braque and Picasso, developed the technique of collage, to some extent as a means of counteracting the loss of reality in Cubist paintings. The immediacy of the non-painterly materials used in collage enabled them to cite and compare various levels of reality in the work of art. The Futurists also made use of this new technique. Futurist collage, however, depended more on the conviction that Futurism by its very nature was compelled to use up-to-date materials. Boccioni had stipulated as much in his *Technical Manifesto of Futurist Sculpture* (1912).

Notes on the Introduction

[1] *Violin and Jug*, Ill. 19 in: E. Fry, *Cubism* (London, 1966); *Violin and Palette*, colour plate 24 in Douglas Cooper, *The Cubist Epoch* (London & New York, 1971).

[2] D. H. Kahnweiler, *Der Weg zum Kubismus* (Stuttgart, 1958), p. 66; see also, *idem*, *The Rise of Cubism* (New York, 1949).

[3] W. Kamlah, *Philosophische Anthropologie. Sprach-kritische Grundlegung und Ethik* (Mannheim, Vienna & Zürich, 1972), p. 77.

[4] Cf. M & D. Gerhardus, *Symbolismus und Jugendstil* (Freiburg im Breisgau, 1977).

[5] Col. plate 5 in D. Cooper, *op. cit.*

[6] Quoted by E. Fry, *op. cit.*

[7] W. Schapp, *Beiträge zur Phänomenologie der Wahrnehmung* (Wiesbaden, 1976), p. 23 ff.

[8] Cf. K. Badt, *Die Kunst Cézannes* (Munich, 1956), ch. iv, pp. 148–73.

[9] Adolf Hölzel (1853–1934), *Katalog der Gedächtnisausstellung zum hundertsten Geburtstag von A. Hölzel.*

[10] W. Kandinsky, 'Über die Formfrage', in: *Essays über Kunst und Künstler* (Berne, 2nd ed. 1963), p. 34; see also, *idem*, *Concerning the Spiritual in Art* (New York, 1947).

[11] Quoted by W. Hess, *Dokumente zum Verständnis der modernen Malerei* (Hamburg, 1956), p. 52.

[12] C. Einstein, *Die Kunst des 20.Jahrhunderts* (Berlin, 2nd ed., 1926), p. 61.

[13] C. Einstein, *op. cit.*, p. 58.

[14] Quoted by G. Burgess, in 'The Wild Men of Paris', *Architectural Record* (New York, May 1910), p. 405 (slightly altered trans.); see also 'Thoughts and Reflections on Art' in *Artists on Art*, eds., R. Goldwater & M. Treves (New York, 1945).

[15] Col. plate 23 in D. Cooper, *op. cit.*

[16] Cf. M. & D. Gerhardus, *Expressionismus* (Basle & Vienna, 1976).

[17] Cf. U. Boccioni, *Pittura, Scultura Futuriste* (Milan, 1914).

[18] Cf. J. Taylor, *Futurism* (New York, 1961).

[19] Cf. *Futurismo 1909–1919* (London, 1972).

[20] W. Baumeister, *Das Unbekannte in der Kunst*, vol. 2 (Cologne, 1960), p. 139.

[21] Cf. *Futurism 1909–1919*, *op. cit.*

[22] Col. plate 64 in M. & D. Gerhardus, *Expressionism, op. cit.*

[23] Cf. J. C. Taylor, *op. cit.*; see also C. Carrà, *La mia vita* (Rome, 1943).

[24] Cf. Taylor, *op. cit.*; *Futurismo 1909–1919*, *op. cit.*

[25] I am indebted to W. Schapp, *op. cit.*, p. 33, for this distinction.

[26] Quoted by W. Hess, *op. cit.*, p. 53.

[27] Cf. U. Eco, *Einführung in die Semiotik* (Munich, 1972), p. 207.

[28] A. von Hildebrand, *Das Problem der Form in der Bildenden Kunst* (Baden-Baden & Stuttgart, 10th ed., 1961), p. 14.

Authors and works cited in the commentary to the colour plates

U. Apollonio, *Futurismus* (Cologne, 1972).

C. Baumgart, *Geschichte des Futurismus* (Hamburg, 1966).

G. Braque, Catalogue of the exhibition at the Haus der Kunst (Munich, 1963).

G. Braque, *Vom Geheimnis in der Kunst* (collected writings etc. in German trans.) (Zürich, 1958); *Cahiers de Georges Braque*, 1917–1947 (Paris, 1948).

P. Cabanne, *L'Epopée du Cubisme* (Paris, 1963).

D. Cooper, *The Cubist Epoch* (London & New York, 1971).

R. Delaunay, Catalogue of the exhibition at the Staatliche Kunsthalle, (Baden-Baden, 1976).

E. Fry, *Cubism* (London, 1966).

J. Gasquet, *Cézanne* (Berlin, 1948).

A. Gleizes & J. Metzinger, *Cubism* (London, 1913).

C. Gray, *The Great Experiment: Russian Art 1863–1922* (London, 1962).

W. Hess, *Dokumente zum Verständnis der modernen Malerei* (Hamburg, 1956).

F. Kupka, 1871–1957, Catalogue of the exhibition, The S.R. Guggenheim Foundation 1975 (Zürich, 1976).

K. Lankheit, *Franz Marc im Urteil seiner Zeit* (Cologne, 1960).

K. Malevich, *The Non-Objective World* (Chicago, 1959).

Short bibliography

G. Apollinaire, *The Cubist Painters* (New York, 1949).

C. Bruni, & M. Drudi Gambillo, *After Boccioni. Futurist Paintings and Documents from 1915 to 1919* (Rome, 1961).

R. Carrieri, *Futurism* (Milan, 1963).

A. J. Eddy, *Cubists and Post-Impressionists* (London, 1915).

E. Fry, *Cubism* (London, 1966).

A. Gleizes & J. Metzinger, *Cubism* (London, 1913).

J. Golding, *Cubism: A History and an Analysis, 1907–1914* (London, 1959).

C. Gray, *Cubist Aesthetic Theories* (Baltimore, 1953).

G. Habasque, *Cubism, A Biographical and Critical Study* (Paris & New York, 1959).

D.-H. Kahnweiler, *The Rise of Cubism* (New York, 1949).

M. W. Martin, *Futurist Art and Theory* (Oxford, 1968).

R. Rosenblum, *Cubism and Twentieth-century Art* (London, 1968).

J. C. Taylor, *Futurism* (New York, 1961).

Short Biographies

Balla, Giacomo

B. 1871 Turin, d. 1958 Rome. Attended evening classes in drawing in Turin. 1895: moved to Rome, illustrations, caricatures, portrait painting; 1900–1901: he was in Paris where he worked with the decorative painter Macchiati; 1901: returned to Rome, townscapes and portraits in Divisionist style. Severini and Boccioni were his pupils; 1910: he signed *Futurist Painting: A Technical Manifesto*. 1912: produced most of his Futurist paintings; influence of Boccioni and the photodynamism of the photographer A. G. Bragaglia; 1915: composed the manifesto *The Futurist Reconstruction of the Universe* (with F. Depero); after the First World War he turned to applied art (fabric designs, designs for clothes, and so on); after 1935 he practised a neo-classicist and figurative style of painting.

Boccioni, Umberto

B. 1882 Reggio Calabria, d. 1916 Sorte, near Verona. Contributed to various journals; wrote an unpublished novel, *Pene dell'Animo*. 1898: moved to Rome, began to paint, worked for a poster painter, studied at the Rome Academy of Fine Arts; 1901: a student with Severini in Balla's studio; 1902 and 1904: in Paris and Berlin; 1906: in St Petersburg; 1907: in Milan, met Carrà, Russolo, R. Romani, G. Previati; 1909: met Marinetti and turned to Futurism; 1910: signed the *Manifesto of Futurist Painting* and *Futurist Painting: A Technical Manifesto*; 1912: took part in the first Futurist exhibition in Paris; 1912: published the *Manifesto of Futurist Sculpture*; 1914: published his essays as *Pittura e Scultura Futuriste*.

Braque, Georges

B. 1882 Argenteuil-sur-Seine, d. 1963 Paris. From 1900 in Paris; 1902–1904: studied at the École des Beaux-Arts and at the Académie Humbert; 1905: met the Fauves, 1907 Picasso; 1908: stayed at L'Estaque, first one-man show at the Galerie Kahnweiler; from 1909 friendship and intensive co-operation with Picasso; 1911–1912: summer holidays with Picasso at Céret (Pyrenees); 1912: took part in the Cologne Sonderbund exhibition; 1914–1915: called up, citation for bravery; 1917: in Sorgues; 1919: exhibition at Léonce Rosenberg's Galerie 'L'Effort Moderne' in Paris; 1924: designs for the ballet; 1933: exhibition at the Basle Kunsthalle; 1937: first prize at the Carnegie Exhibition in Pitts-burg; 1939: retrospective in Chicago, Washington, San Francisco; 1953: ceiling paintings at the Louvre.

Carrà, Carlo

B. 1881 Quarigniento (Piedmont), d. 1966 Milan. 1893: apprentice decorator; 1900: in Paris as decorator for the International Exhibition, in London for a short time; 1904: return to Milan, studied at the Accademia Brera; 1908: met R. Romani, Russolo, Boccioni; 1909 frequented Boccioni and Marinetti; 1910: signed *Manifesto of Futurist Painting* and *Futurist Painting: A Technical Manifesto*; 1911: visit to Paris, met Apollinaire and the Cubists; 1912: took part in the Futurist Exhibition in Paris; 1913: published his *Manifesto of Painting, Tones, Sounds and Smells*; 1915: published his essays under the title *Guerra Pittura*; 1915: national service; 1916: met G. de Chirico.

Cézanne, Paul

B. 1839 Aix-en-Provence, d. 1906 Aix-en-Provence. 1858–1860: studied law and worked at the school of drawing in Aix; 1861–1862: studied at the Académie Suisse in Paris, renewed a youthful friendship with Zola, met the Impressionists; 1862–1872: alternately in Paris and Aix-en-Provence; 1872–1874: with Camille Pissarro in Auvers-sur-Oise; 1874 and 1877: exhibited with the Impressionists; from 1881 mostly in Aix-en-Provence; from 1882 often in L'Estaque; 1895: first retrospective at Vollard in Paris.

Delaunay, Robert

B. 1885 Paris, d. 1941 Montpellier. 1902: trained as theatrical painter; 1903–1904: joined the Fauves, friendship with Metzinger and Rousseau; from 1909 joined the Cubists, began the series of Eiffel Tower studies; 1911: member of the Section d'Or, took part in the Blaue Reiter exhibition in Munich; 1912–1913: great success in the Salon des Indépendants with the picture *La Ville de Paris*; 1914–1920: visited Spain and Portugal; 1920–1935: in Paris, friendship with Surrealists Breton, Aragon, Tzara; 1932: helped to found the Abstraction–Création group; 1936: exhibited at the Cubism and Abstract Art show at the Museum of Modern Art, New York; 1937: decoration for the rail and air travel pavilion at the Paris International Exhibition.

Delaunay-Terk, Sonia

B. 1885 southern Russia, d. 1967 Paris. 1910: married Robert Delaunay; 1912: first collages, initially as book covers for Apollinaire, Cendrars, Rimbaud; fabric designs ('simultaneous' clothes); 1914–1920: in Spain and Portugal with Robert Delaunay; a major influence on fashion in the Twenties; designs for Diaghilev's Russian Ballet.

Derain, André

B. 1880 Chatou, d. 1954 Chambourcy. Studied drawing under Jacomin in Chatou; 1898: studied at the Académie Carrière, from 1904 at the Académie Julian in Paris; 1905: took part in the Fauves' exhibition at the Salon d'Automne; 1908: met Picasso and his circle, encouraged by Kahnweiler; from 1912 painted mainly figurative work; took part in the Cologne Sonderbund exhibition; 1920: visited southern France and Italy.

Duchamp, Marcel

B. 1887 Blainville near Rouen, d. 1968 Neuilly-sur-Seine. Trained as librarian and studied at the Académie Julian; 1909: turned to Cubism; 1911: member of the Section d'Or; 1914: first 'ready-mades'; 1915: visited the USA, met Picabia; 1915–1923: worked on his monumental glass picture *The Bride Stripped Bare by her Bachelors, Even*; 1917: edited the journals *The Blind Man* and *Wrong-wrong*; 1920: attempts at abstract film-making; 1928: stopped painting; organized major art exhibitions.

Gleizes, Albert

B. 1881 Paris, d. 1953 Avignon. From 1906 abandoned Impressionism, from 1910 under the influence of Cubism; 1911: met Picasso, took part in the Section d'Or meetings; 1912: published (with Metzinger) *Du Cubisme* in Paris (*Cubism*, London 1913); 1913: exhibited at the German Herbstsalon at the Sturmgalerie, Berlin; 1914: national service; 1915: visited New York; 1919: returned to Paris; 1923: published *La Peinture et ses Lois*, Paris; from 1917 tried to put painting at the service of the Catholic Church; 1950: exhibited in *L'Art Sacré* in the Vatican.

Goncharova, Natalia Sergeievna

B. 1881 Ladishino near Tula, Russia, d. 1962 Paris. From 1898 studied sculpture at the Moscow School of Painting, Sculpture and Architecture; 1900: met the Russian Fauve Larionov; 1904: turned to painting, studied icons and Russian peasant art, married Larionov; 1906: took part in the Russian exhibition organized by Diaghilev at the Salon d'Automne in Paris; from 1910 reacted against Cubism and Futurism; 1913: published (with Larionov) the Rayonnist manifesto; 1913: visited Paris; from 1913 mainly concerned with stage designs for Diaghilev's Russian Ballet; 1914: returned to Moscow; 1915: moved to Paris.

Gris, Juan

B. 1887 Madrid, d. 1927 Boulogne-sur-Seine. 1902–1904: studied at the Escuela de Artes y Manufacturas in Madrid; 1906: moved to Paris, met Picasso, Max Jacob, Apollinaire; 1911: first oil painting; 1912: showed at the Salon des Indépendants, contract with Kahnweiler for his entire output; 1914: friendship with Matisse, Marquet and Gertrude Stein; 1915–1916: illustrated Reverdy's *Poème en Prose*; 1917: met Jacques Lipchitz, some sculpture; 1920: published an essay on negro sculpture; 1922–1924: stage designs for Diaghilev's Russian Ballet; 1923: published *Notes sur ma Peinture*, Paris; 1924: lecture at the Sorbonne on the possibilities of painting; 1925: published *Chez les Cubistes*, Paris.

Kupka, Frantisek

B. 1871 Opocno (eastern Bohemia), d. 1957 Puteaux (France). 1889: studied at the Prague Academy, 1892 at the Vienna Academy; 1896: moved to Paris, met Mucha; 1899: decided to become professional illustrator, became known for the series *Money, Peace, Religion*; from 1900 exhibited at the Salon d'Automne and Salon des Indépendants; 1910: published *Futurist Painting: A Technical Manifesto*; 1911: took part in the Section d'Or discussions; first abstract painting *La Fugue en Rouge et Bleu*; 1931: founded the Abstraction-Création group with T. van Doesburg, A. Herbin, Gleizes, and others.

La Fresnaye, Roger de

B. 1885 Le Mans, d. 1925 Grasse. Trained as a mathematician; 1903: studied at the Académie Julian and the École des Beaux-Arts in Paris; 1908: studied under P. Sérusier and Maurice Denis at the Académie Ranson in Paris; 1910: made a study of Cézanne's painting; 1911–1912: turned to Cubism; 1914–1915: national service, volunteered; 1919: severe illness; only watercolours after 1919.

Léger, Fernand
B. 1881 Argentan (Normandy), d. 1955 Gif-sur-Yvette. 1900: moved to Paris; 1900–1902: Architectural drawing; from 1903 studied at the Académie Julian; 1909: met Archipenko, Lipchitz, Delaunay, Rousseau, came into contact with the Section d'Or; 1910: met Kahnweiler; 1914–1917: national service; 1921–1924: first stage and film décors; from 1925 decorative murals; from 1930 travel, stage designs, murals; 1940–1945: in the USA, Chair at Yale; 1945: returned to Paris; 1946–1949: designed church façade at Assy; 1952–1954: designed the great hall of the UN building in New York; first ceramics in 1950.

MacDonald-Wright, Stanton
B. 1890 Charlottesville (USA), d. 1975 Los Angeles. 1907: moved to Paris, studied at the École des Beaux-Arts and at the Académie Julian; 1912: founded, together with the American painter M. Russell, the mode of painting known as 'Synchromism'; first Synchromist exhibition at the Carroll Gallery, New York; 1913: took part in the Armory Show in New York, and showed in the Salon des Indépendants; 1916: returned to the USA; 1919–20: reverted to figurative painting; 1937: visited Japan; from 1937 taught eastern and modern art at the University of California and Los Angeles; from 1954 returned to abstract painting.

Malevich, Kasimir Severinovich
B. 1878 Kiev, d. 1935 Leningrad. From 1895 studied at the Kiev Art School; from 1909 critical engagement with Cubism and Futurism; 1913: founded 'Suprematism'; 1918–1919: member of the Fine Arts Committee of the People's Education Commissariat, taught at the 'First State Free Art Workshops' in Moscow; 1919–22: taught at the Vitebsk 'Practical Artistic Institute'; 1923–1927: director of the 'State Institute for Artistic Culture' (the former Academy) in Moscow; 1926: visited Germany, met Kandinsky at the Bauhaus.

Marc, Franz
B. 1880 Munich, d. 1926 (at Verdun). 1900–1903: studied at the Academy in Munich under Hackel and Diez; from 1909 in Sindelsdorf (upper Bavaria), from 1914 in Ried (upper Bavaria); 1910: friendship with Macke; 1911: published (with Kandinsky) the Blaue Reiter almanac; 1912: co-founder of the Blaue Reiter group of artists, met Robert Delaunay; 1914: national service.

Marcoussis, Louis (Markus, Louis Casimir Ladislas)
B. 1883 Warsaw, d. 1941 Cusset (Allier, eastern France). Studied law and art in Cracow; 1903 moved to Paris, pupil of Lefébvre's; 1907–1910: illustrations and caricatures; 1910: met Picasso and Braque, acquaintance of Juan Gris; began to paint again, especially townscapes; 1912: joined the Section d'Or, exhibited at the Salon d'Automne; book illustrations for Max Jacob, Tristan Tzara, Paul Eluard.

Metzinger, Jean
B. 1883 Nantes, d. 1956 Paris. 1903: moved to Paris, influence of neo-Impressionism; 1910: met the Cubists; 1911: showed at the Salon des Indépendants; 1912: joined the Section d'Or; 1912: published *Du Cubisme* with Gleizes (*Cubism*, London 1913); *c.* 1920: painted in Neue Sachlichkeit style, subsequently returned to Cubist techniques.

Mondrian, Piet
B. 1872 Amersfoort (the Netherlands), d. 1944 New York. 1892: passed examination as teacher of drawing; 1892–1894: studied at the Rijksakademie in Amsterdam; 1900: visited London and Spain; 1910: founded the Moderne Kunstkring with C. Kickert, J. Sluyters and J. Toorop; 1911: participated in Salon des Indépendants, moved to Paris; influence of Picasso and Léger; 1914: returned to the Netherlands; 1915 met van Doesburg; 1916–1917: founded De Stijl with T. van Doesburg and issued the journal of the same name, published *The New Form in Painting* in the first issue; 1919: returned to Paris, published his articles as *Neo-plasticism*; 1925: left De Stijl; published on *Jazz and Neo-plasticism*; 1931: joined Abstraction-Création group with Kupka, Arp, Herbin and others; 1938: emigrated to London and 1940 to New York.

Picabia, Francis
B. 1879 Paris, d. 1953 Paris. Studied at the École des Beaux-Arts and the École des Arts Décoratifs in Paris; 1911: member of the Section d'Or; 1912: influence of Orphism; 1913: met Duchamp; 1914–1916: visit to New York, 1916 in Barcelona, then Zürich; co-founder of the Zürich Dada group; edited the review *391*; 1918: in Paris, associated with the Surrealists; 1922: published *Pomme du Pin*; 1925: returned to a form of fantastic-figurative painting; from 1945 produced abstract paintings again.

Picasso, Pablo (Pablo Ruiz Blasco)
B. 1881 Málaga, d. 1973 Monguins. 1896: studied under his father at the 'La Lonja' art school in Barcelona; 1897: at the Academy in Milan; 1900, 1901, 1902: visits to Paris; 1904: moved to Paris; 1906: friendship with Apollinaire; 1907: first Cubist picture, *Les Demoiselles d'Avignon*; 1907: met Braque; 1909: first exhibition of Picasso's paintings in the Tannhäuser Gallery, Munich; 1911–1912: summer holiday with Braque in Céret; 1911: first exhibition in the USA; 1912: first collages; 1915–1916: in addition to Cubist paintings returned to figurative painting; 1917–1924: theatre designs, for Diaghilev's Russian Ballet; 1925: took part in the first Surrealist exhibition; 1936: appointed Director of the Prado, Madrid, returned to Paris the same year after Franco's victory; from 1946 on the Côte d'Azur; 1946–1954: mainly ceramics; 1970: the Picasso Museum opened in Barcelona; 1971: retrospective at the Louvre—the first exhibition there of the works of a living artist.

Russolo, Luigi
B. 1885 Portoguaro, d. 1947 Cerro di Laveno (Lake Maggiore). Studied music; from 1909 took up painting, friendship with A. Bonzangi and R. Romani; 1910: met Marinetti, worked on the journal *Poesia*; met Boccioni and Carrà; signed the *Manifesto of Futurist Painting*; 1913: published *The Art of Noise*; 1913–1914: concerts in Italy and abroad; 1915: volunteered for the army; 1917: seriously wounded; from 1924 figurative painting.

Severini, Gino
B. 1883 Cortona, d. 1966 Paris. From 1889 in Rome, 1900: met Boccioni, studied in Balla's studio; 1906: visited Paris, met Modigliani and Max Jacob; 1910: signed the *Manifesto of Futurist Painting*; met Picasso; 1912: took part in the first Futurist exhibition in Paris; 1914: returned to Paris; 1921: published *Du Classicisme*, Paris; turned to a form of 'neo-Classicist' figurative painting; from 1930 reverted to abstract painting; 1936: published *Ragionamenti sulle Arti Figurative*, Milan.

Villon, Jacques (Gaston Duchamp)
B. 1875 Damville (Eure), d. 1963 Puteaux. From 1894 in Paris, studied at Atelier Cormon; produced humorous drawings for various papers; 1911: met the Cubists; 1912–1914: member of the Section d'Or; 1914–1919: national service; from 1920 mainly graphic art; 1930: returned to painting; 1935: visited the USA; 1940: left Paris; 1950: awarded the Carnegie Prize.

PLATES

There are several reasons for starting a set of illustrations to a book on Cubism and Futurism with the work of Paul **Cézanne.** Cézanne is rightly thought of as the 'father of modern art', and of modern painting in particular, and quite diverse movements and trends derive from him. Artists and critics also generally refer to the middle and late phases of Cézanne's work when they cite—as they often do when discussing the meaning of Cubism—his remark in a letter of April 15, 1904 to the Symbolist painter Emile Bernard: '... treat nature in accordance with the cylinder, sphere and cone, and bring everything into proper perspective so that each side of an object or a plane is directed towards a central point' (*Letters*, London, 1941, p. 234). Apart from the fact that Cézanne is not recommending that nature should be painted *as* cylinders, spheres and cones, and that such a course can hardly be said to have been followed strictly by any Cubist painter, his contributions to the development of Cubism lie elsewhere.

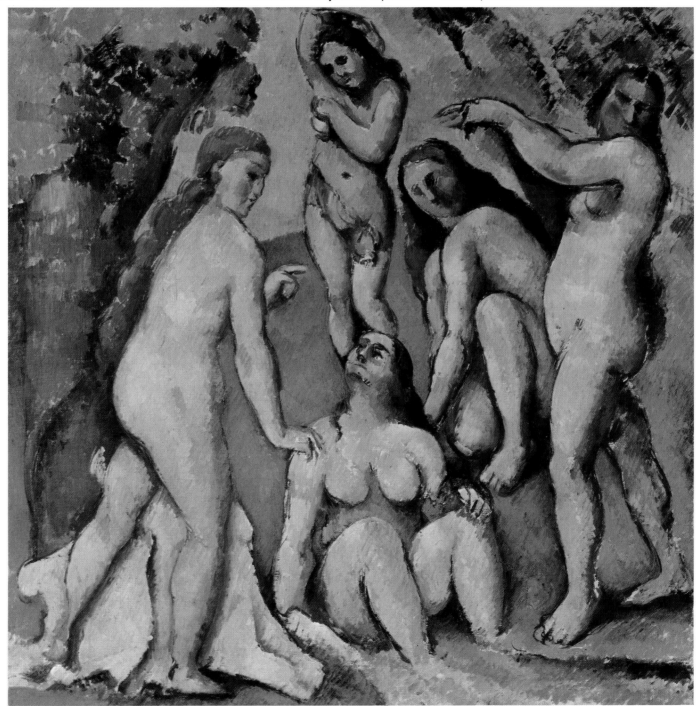

1 Paul Cézanne
Women Bathers,
1885/1887
Oil on canvas,
65.5×65.5 cm
Basle, Kunst-
33 museum

The main notion of Cézanne's art is as follows: since no artist can ever succeed in copying nature pure and simple by trying to reproduce its every trait on the canvas, his purpose must be instead to *represent* nature with the means proper to painting. An artist is concerned with the conception and organization of an arrangement in paint. *Women Bathers* and the two Montagne Sainte-Victoire pictures show that it is the artist's intention to work out a system of coloured signs and use them in a process known as painting. Cézanne called them 'coloured equivalents'. In order to make the most effective pictorial use of these 'equivalents', Cézanne dispensed increasingly with any definite linear contours when representing objects. For instance, the limits of the nudes in *Women Bathers* are determined by colours and therefore can only be deciphered in terms of colour. The 1904–1907 *Montagne Sainte-Victoire* depends on the same kind of non-linear, uncontoured painting which instead of showing objects as distinct entities, represents them as a single colour composition. The structure of the picture is decided by colour, and is built up by means of patches of colour (*plans* or *taches*) varying considerably in shape and size. What Cézanne called 'sensations colorantes' are used to give the picture both formal structure and significant colour. These elements of visible form are not only basic components of the picture but are invented and produced solely for the picture. The two landscapes illustrated here show very clearly that the way in which colour is used to shape objects is no longer separable from the way in which it gives a picture its specific density. Cézanne structures colour freely so as to give it a value within a particular painting, and at the same time divorces it effectively from the objective system of the visible world. In other words: patches of colour are applied and a unique composition comes into being in order to *represent* nature rather than to *copy* it. The application, arrangement and direction of the colour patches occur simultaneously in one and the same action of painting in one and the same picture.

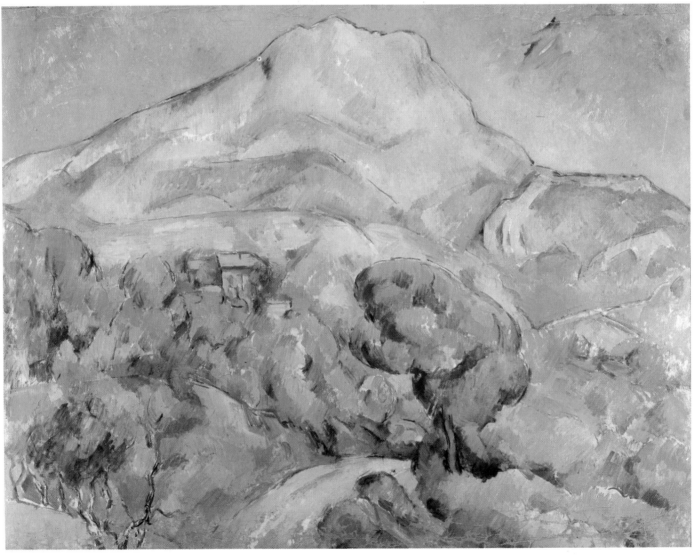

2
Paul Cézanne
Montagne Sainte-Victoire,
1898–1900
Oil on canvas,
60×73 cm.
Leningrad,
Hermitage

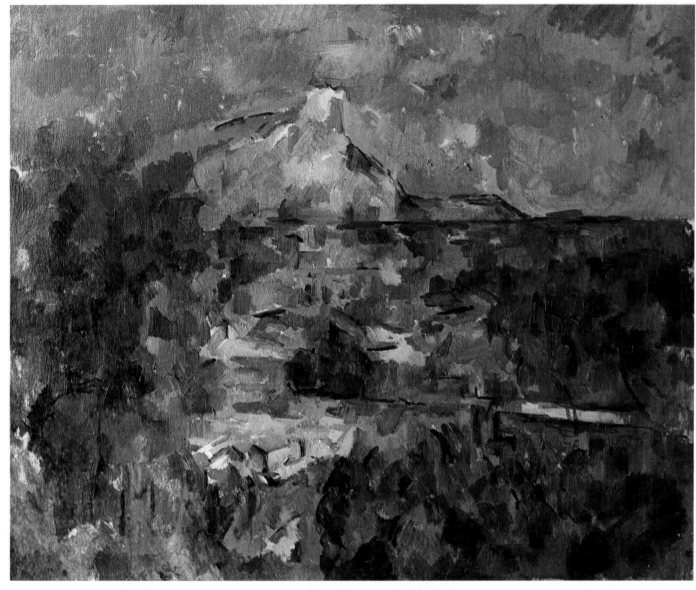

**3
Paul Cézanne**
*Montagne
Sainte-Victoire,*
**1904/1906
Oil on canvas,
60×72 cm.
Basle,
Kunstmuseum**

Joachim Gasquet has recorded three conversations with Cézanne in which the painter explains that this way of constructing a colour composition is the central theme of his art: 'There we are! ... (He repeats the movement, opens his hands and extends all ten fingers, slowly, slowly draws them towards one another, closes them, presses them together, tightens them and makes one all but bore into the other). That's what you have to do. If I move too high or too low, it's all wrong. Not one part must be out of true; there must be no chink through which arousal, light, truth can penetrate. I work the whole picture uniformly, you see, as a whole. I bring everything that tends to move apart into one rhythm and one conviction ... (Gasquet, p. 9).

Here Cézanne states that colour is the sole basic element of pictorial art which enables a painting to be produced as a wholly self-sufficient complex, without any recourse to a linear support in the organization of the picture. In constructing the picture, the painter applies, arranges and relates the *taches* of colour in a way unique to each painting, so that with each work he begins a new process. He is producing 'constructions from nature' (Cézanne).

In the early Cubism of Picasso (Ill. 4–9) and Braque, on the other hand, the common method is a step-by-step process concerned initially with a representational use of forms derived from geometry and stereometry but specific to the painting in each case. Picasso and Braque were primarily interested in compiling a repertoire of basic pictorial elements which were combined in early Cubism and then applied in the stage of analytical Cubism in accordance with rules and demands immanent to each painting as it came into being.

Pablo **Picasso** transformed the practice of art with an often clairvoyant imaginative power. He asked exactly how artists could and ought to proceed in drawing, graphics, painting and sculpture.

Picasso more than any other artist succeeded in bestriding the 'isms' of the first thirty years of the twentieth century, in reducing them to essential questions and combining them, as it were, while keeping his own 'signature' on all he produced. The general public often use the name 'Picasso' as a portmanteau term for almost any aspect of modern art—whether to approve or to decry.

4 Pablo Picasso
Les Demoiselles d'Avignon, **1907**
Oil on canvas, 244×233 cm
New York, Museum of Modern Art,
Lillie P. Bliss Bequest

Picasso began quite naturally, so it seems, with classical canons and passed into the great investigative freedom and excitement of Dadaism. He wholeheartedly maintained the new-found rigour of Cubist construction only to pass on to the fantasy-world of Surrealist ideas of pictorial imagery. His method of improvisation depended as much on unfettered 'automatism'—or release of subconscious fantasy—as on optimal spontaneity of impulse. Unlike almost any other artistic personality in our century, Picasso evoked reactions ranging from entirely uncritical discipleship to utter rejection. It is hardly surprising that artists of the most diverse backgrounds and artistic persuasions should be prepared to pay homage to Picasso—as in the exhibition entitled *Hommage à Picasso* and shown at the time of the painter's ninetieth birthday in several cities of Europe.

Even though Picasso's extremely versatile work may be divided and subdivided into various phases, it can also be seen as a set of staging-posts along a single route of development. Picasso himself said of the first major period of his evolution as an artist: 'We were all *Art Nouveau* painters'. His works between 1901 and 1904, the so-called Blue Period, were certainly indebted in line and pattern as well as colour-scheme to the various trends of the 'Modern Style'.

The main theme, however, was man marked by suffering, hunger and loneliness—a topic that had hardly appeared thus in European Symbolism or Art Nouveau. The fine, extended line describes often melancholic midnight-blue figures and emphasizes their depressive or consumptive appearance, as for instance in *Portrait of Jaime Sabartès* (1901), *The Embrace* (1903) or *Woman Ironing* (1904). Picasso finally moved to Paris in 1904. He took a studio in the barracks-like wooden house in Montmartre which became famous as the 'Bateau Lavoir'. It became a constant meeting place for writers and artists, among them Apollinaire, Max Jacob, André Salmon, Derain (Ill. 38), Kees van Dongen and Juan Gris (Ill. 17—22), and, after 1907, Braque (Ill. 10—16). Between 1904 and 1906 Picasso's palette changed to light blue, bright pink and reddish ochre. In this 'Rose Period', he mainly painted scenes from circus and artists' life, including the famous *Family of Saltimbanques* of 1905.

In 1906–1907 Picasso was concerned above all with the works of Cézanne and the Fauves. Primitive sculpture—carved figures of the Bakota, or the Gaboon and Guro carvings—fascinated and inspired Picasso, Derain, Matisse and the German Expressionists. Picasso also studied Cycladic art. This interest of artists who also collected primitive work was closely connected with the beginnings of research into popular or tribal art shortly after 1900. The hard contours, sculptural emphases and preference for earth colours in Picasso's work in this period, that of his 'Iberian' or 'Negro' art, prepared the way for Cubism. His *Self-Portrait with Palette* (1906) is a good example of this stage of development in his work.

Les Demoiselles d'Avignon of 1907 was the start of Cubism, which proved to be one of the three great movements of renewal in the visual arts during the first quarter of this century. This painting of Picasso's had a unique influence on the course of Cubism, though it was exhibited for the first time thirty years after completion. The present title was supplied by a writer friend of Picasso's around 1920 and refers to the inmates of a brothel in the Carrer d'Avinyó (or Avignon Street) in Barcelona.

The pictorial representation of a brothel scene, which was the basis of the painting, shows Picasso's interest in life on the margin of society which was characteristic of his 'Blue' and 'Rose' periods. His method here is partly experimental, but draws to some extent on El Greco's style with its somewhat

5 Pablo Picasso
Three Figures under a Tree, **1907**
Oil on canvas, 99×99 cm. Private Collection

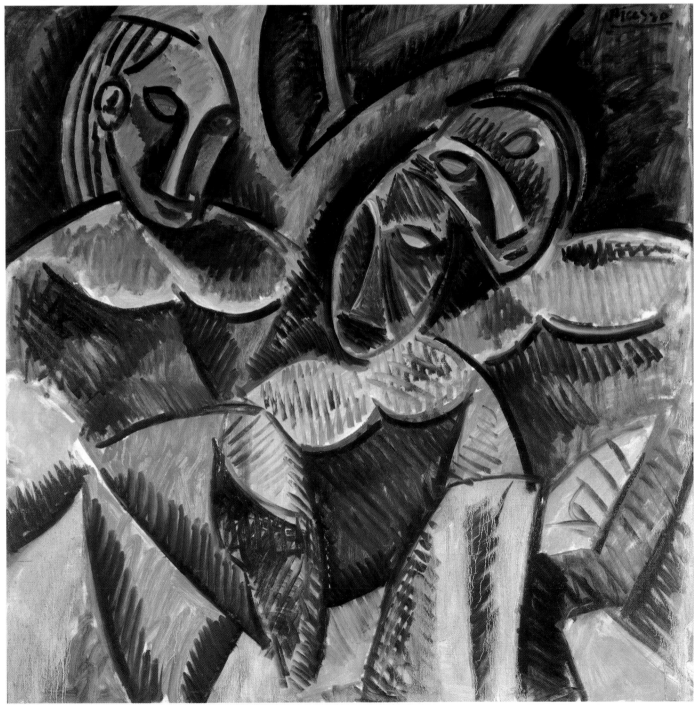

ethereal, elongated figures, as well as on Gauguin's sculpture and on African art. The convention of central perspective that had ruled since the Renaissance and in accordance with which the eye is the centre and the objects of the perceptual world are projected in terms of apparent reduction in size, foreshortening and convergence of lines on the vertical plane, is only residually present in Picasso's work, as it had been in

6 Pablo Picasso
Family of Harlequins, **1908**
Oil on canvas, 88×98 cm
Wuppertal, Von-der-Heydt Museum

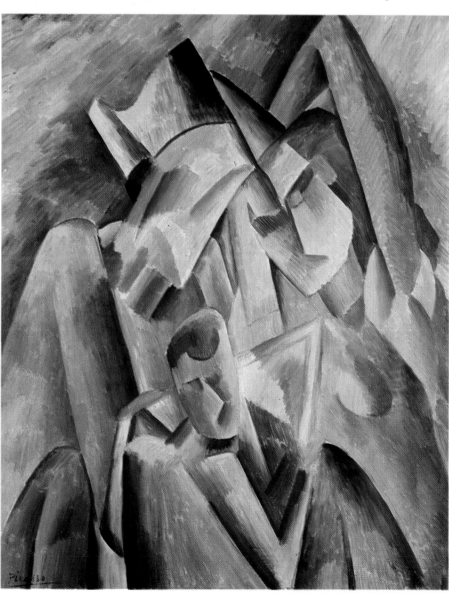

Cézanne's. In the *Demoiselles* everything seems to be brought to the surface, and space is determined mainly by a superficial recession obtained by superimposing the figures slightly. From left to right, we see first three standing female nudes. The one on the far left is in profile; one hand hangs down by her side and the other is raised above her head; she is putting one leg forward. The other two are more or less frontal views; one has one arm, the other both arms, raised: in the second case the angular arms disappear behind the head. From the observer's position, the central figure of the trio is holding a cloth over her left thigh. The lower part of the

body of the figure in the very middle of the picture is also largely covered by a white cloth. Two more nudes take us up to the right-hand edge of the painting: one is sitting in the lower corner of the picture whereas the other has a three-quarters profile facing left and is half-obscured by the sitting figure. In the immediate foreground a triangular plane juts out into the picture from the lower edge and serves as a background for an arrangement of fruits (a slice of melon, grapes, an apple and a pear). The rust-coloured 'backcloth' to the left and the blue ones on the right act in a sense as stage-curtains if we go on looking at the painting in a figurative way.

Anyone reading this quasi-objective description without looking at the actual painting will find it difficult to accept that not only Picasso's writer friends but avant-garde artists, such as Matisse, Derain and especially Braque, were suspicious and uncomprehending when faced with the *Demoiselles*. Only an extended description will show how the content and form of the painting diverge from traditional norms. Instead of a curved line imitating the female form, the observer is presented with an anatomically radical treatment of the figures which distorts the relation between the body mass and individual features such as joints, breasts and faces. The sudden angles are acceptable as painting pure and simple, but depart grossly from the customary notion of a female nude and therefore shock the observer. The apparently fragmented colour and shape of the background increase this impression and the irregular upper and lower extremities of the figures have the same effect. Instead of the expected anatomically correct bodies and general verisimilitude, we have almost geometrical shapes, and instead of expressive gestures an attempt has been made to arrange the human figure less from an imitative viewpoint than from that of what is right for the picture. The intention is to organize it so that the painting as a particular optical image replaces the picture as a copy or imitation of life as it is.

The noses are in profile in the faces of the two central nudes, which are rendered *en face*. In portraying countenance the painter

38

has restricted himself to the basic elements proper to a face: eyes, nose, mouth and ears, and thus approximates the heads of primitive sculpture. The coloured diagonals inserted into the faces of the two right-hand nudes heighten this process of pictorial reduction so that they look like two masks. At the same time cross-hatching, instead of the traditional light-dark contrast, is used to render volume. All painterly techniques unite in a common attempt to destroy any equation of visible world with pictorial representation. The intention is to make the picture as a whole an autonomous optical configuration which no longer corresponds to anything in the real world outside the painting. Cézanne (Ill. 1–3) produced a form of painting entirely reliant on colour; Picasso's painting was determined by form and plane.

From this point on, Picasso consistently developed the organization of the picture in terms of planes. For instance, in *Three Figures under a Tree* and in the *Family of Harlequins* he reduced his colour plan, which in the *Demoiselles d'Avignon* was still reminiscent of his 'Blue' and 'Rose' periods, to a mainly brownish-grey-green scale. At the same time he experimented with the possibility of using planes as elements to render volume. In *Three Figures under a Tree* Picasso was also working with broad coloured cross-hatching of the kind used in the two right-hand figures of the *Demoiselles*. The variations in the coloured cross-hatching and a broad contour confer a semi-decorative effect to the surface plane; the individual components of these underlying devices are to some extent figurative and objective (e.g., faces) but also non-objective (e.g., the shapes at the lower and upper edge of the picture). The interplay of variously cross-hatched areas has the effect of simultaneously evoking volumes which imitate parts of the body and those which are free in the sense that their only purpose is to help organize the picture.

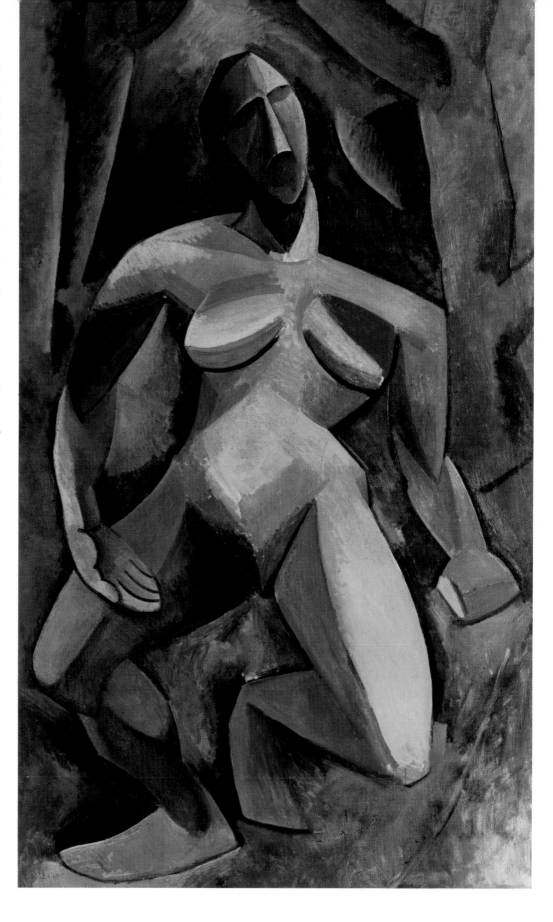

7 Pablo Picasso
Nude in a Forest (Large Dryad), **1908**
Oil on canvas, 186×107 cm
39 **Leningrad, Hermitage**

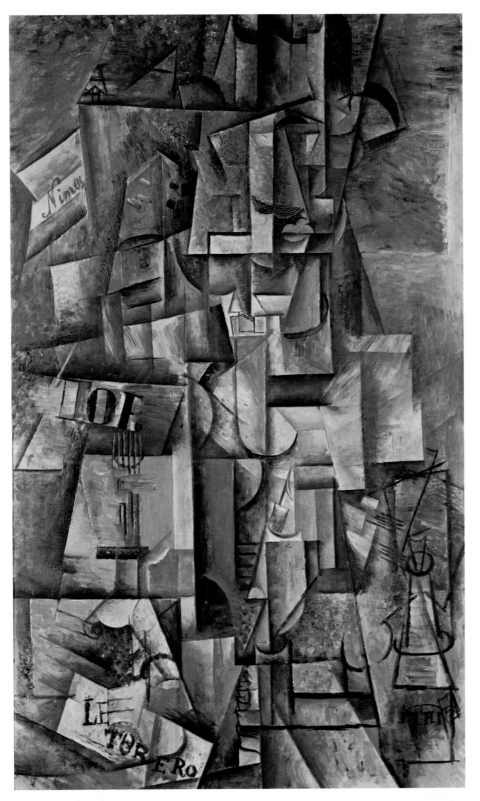

Picasso's method of offering a double visual aspect in a painting—copying the objective aspect of the visually apprehended real world, and at the same time developing the organization of forms with their own independent life within the painting—is concentrated and refined in the *Family of Harlequins*. It is fully realized in *Nude in a Forest* (*Large Dryad*), and we have already shown how in the Introduction. This painting is a major achievment of the early Cubist conception of art. Here the use of part-forms which remind one of ideal objects from geometry and stereometry and yet serve to portray a single 'imitative' female nude is successful and already reveals the form of autonomous pictorial composition that was to dominate the further development of Cubism.

In *The Torero* Picasso also achieves an essentially non-objective multi-planar resolution of the entire picture surface. This work should be counted among the products of analytical Cubism inasmuch as here artistic means are used to dissect shape and figure without any attempt at imitation, while at the same time there is a definite residual reference to the actual visual world.

The danger of the picture shattering into fragments because of the often microscopic division of Cubist elements is decisively avoided. The determinedly *vertical* construction of the picture ensures this in its perfect accord with the vertical format. This stress on, and elongation of, the verticals, and sometimes even of the horizontals, as an optically emphatic means of consolidating the structure and arrangement of artistic devices specific to the picture itself is a constant characteristic of Cubism. It can be seen not only in Picasso's *Nude in a Forest* or *The Violin*, but, for instance, in Braque (Ill. 11, 13, 14), Gris (Ill. 17), Kupka (Ill. 37) or Derain (Ill. 38).

The Violin of 1913, clearly a favourite Cubist motif for Picasso, Braque and Gris, is

8 Pablo Picasso
The Torero or the Aficionado, **1912**
Oil on canvas, 135×82 cm
Basle, Kunstmuseum

40

a good example of the typical use of conventionally non-painterly materials, such as strips of paper, newspaper, oil-cloth, glass, sawdust, and so on (and, in this case, gesso and sand). This collage technique enables the materials to be used mainly for their objective nature, their 'thinginess'. In this picture the meticulous illusionism of the painted wood offers an extreme contrast with the actual, rather than the copied, materials, so that the different methods used in the various areas of the picture achieve an interplay of degrees of reality and representation, just as in the process of contemplating the picture they interrelate and unite what can be seen and what can be felt.

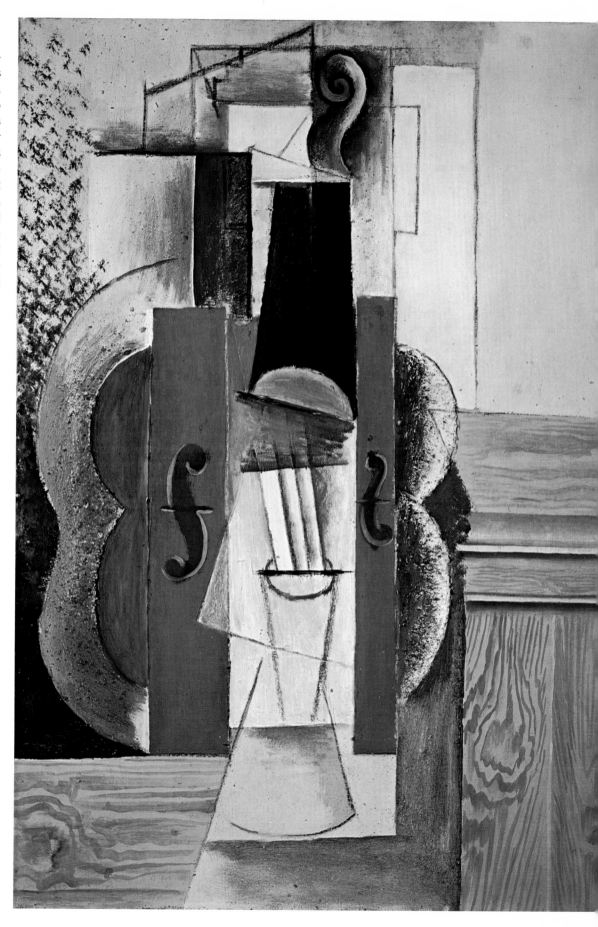

9 Pablo Picasso
The Violin, **1913**
Oil, gesso and sand on canvas, 65×46 cm
Berne, Kunstmuseum
41 **Hermann and Margrit Rupf Foundation**

You should not imitate what you want to create'. This watchword of **Braque's** characterized his work throughout the greater part of his life. He was always convinced that artistic invention is important whereas mere copying is not. He was not interested in portraying arbitrary facts and events in the visible world, but in the artistic production of a 'fait pictural', an artistic fact.

10 Georges Braque
Landscape near L'Estaque, **1908**
Oil on canvas, 46×38 cm
Paris, Musée National d'Art Moderne

In this artistic activity, the painter tried to 'unite', as it were, with nature, in order to represent it with the artistic means that he himself had devised and developed.

Guillaume Apollinaire took George Braque to Picasso's studio towards the end of the year 1907. At first he was shocked by Picasso's *Les Demoiselles d'Avignon* (Ill. 4). Shortly afterwards, however, he began to see its virtues and to show its influence in his own work. The effect on Braque's painting is obvious in the picture already mentioned in the Introduction: *Grande Nue* (1907–1908). This painting has a key position in Braque's

work as a foundation stone of Cubist art, along with Picasso's *Les Demoiselles d'Avignon*.

In summer 1908 Braque visited L'Estaque for the third time. There he painted landscapes such as *Landscape near L'Estaque* (Ill. 10), *Houses at L'Estaque* (Ill. 12) and still lifes such as *Still Life with Coffee Jug* (Ill. 11). The initially bright palette he used was still influenced by the strident colour scale of the Fauves—'Matisse and Derain opened up the way for me', said Braque—but later it changed to green, ochre, grey and black. Heavy, angular and often broad lines are used to delineate forms rather than the loose and soft, rounded emphases of earlier work. At the beginning of the Cubist movement, Braque's and Picasso's paintings were similar in style, as can be seen by comparing Braque's *Landscape near L'Estaque* with Picasso's *Three Figures under a Tree* (Ill. 5). The coloured hatching in each case is almost interchangeable in the coarseness and width of the brushstrokes, the muted colour, and the stress on directional lines intended to describe essential volumes. Both pictures also show that it is impossible to paint non-imitative volumes in this particular way, unless painters are prepared to allow the picture to slip into pure decoration.

Houses at L'Estaque is a particularly good example of how Braque, like Picasso, abandoned the technique of central perspective, which demands that the painter should take up a fixed standpoint in regard to the objects he is about to depict. The fixed viewpoint is replaced by a self-sufficient structure of coloured areas and space; it is very difficult to relate such structure to a fixed spot external to the picture itself, as the 1909 photograph 'L'Estaque' by D. K. Kahnweiler of exactly the same piece of landscape shows. A point outside the picture has to some extent been taken into consideration in the piling up of angular volumes from bottom right to top left, and becomes

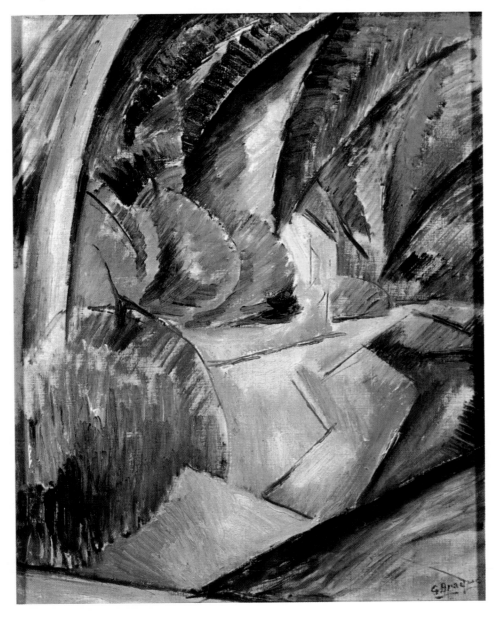

Right:
11 Georges Braque
Still Life with Coffee Jug, **1908**
Oil on canvas, 46×38 cm
Stuttgart, Staatsgalerie

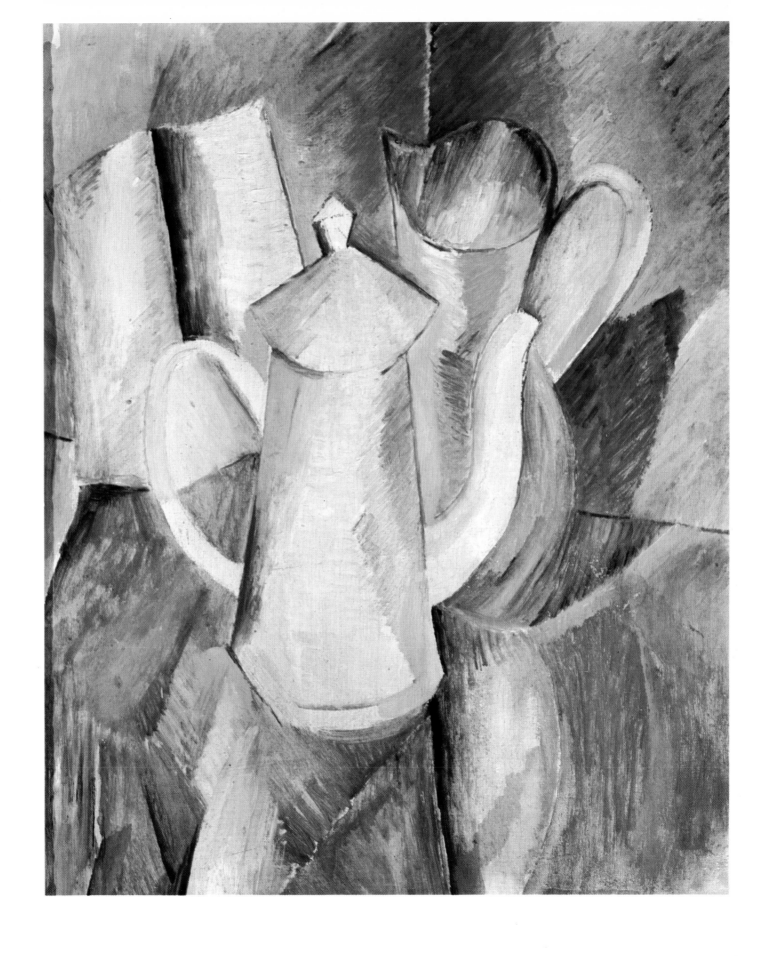

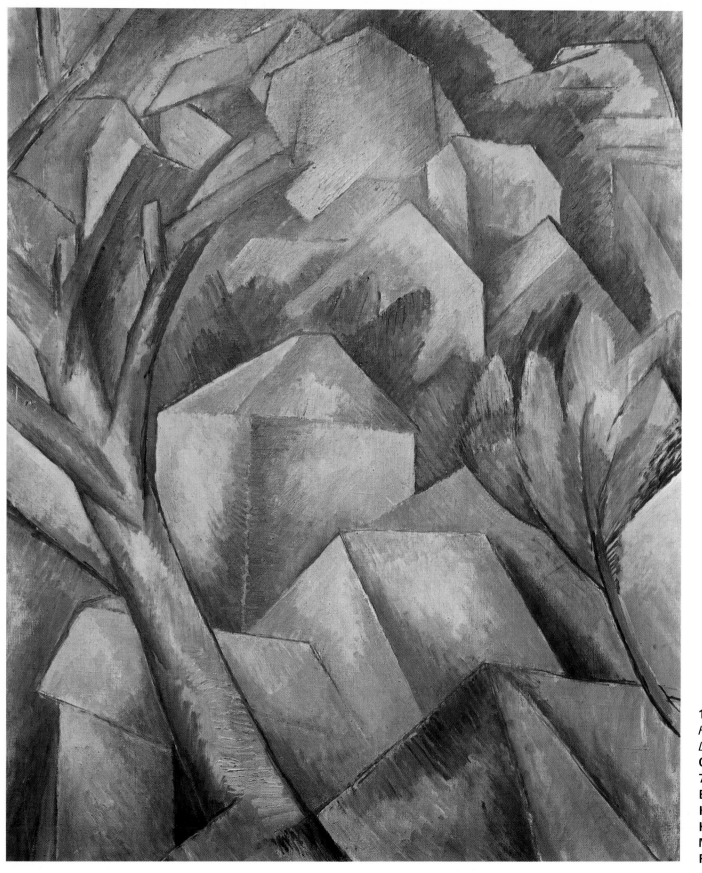

12 Georges Braque
*Houses at
L'Estaque*, **1908**
**Oil on canvas
73×60 cm
Berne,
Kunstmuseum
Hermann and
Margrit Rupf
Foundation** 44

inseparable from their varied inclination towards the surface of the painting. Braque rejected traditional norms in order to control the structure and composition of the painting, and show the physicality and manipulability of objects; the extent to which he did so, both in *Still Life with Coffee Jug* and in *Houses at L'Estaque*—and the degree to which colour was dislodged from its rôle of simultaneously distinguishing form and accompanying it, is clear from the painter's own testimony: 'Conventional perspective didn't satisfy me. Its mechanical nature never allows full possession of things. It begins with one particular standpoint and never leaves it. But the standpoint is really something fairly unimportant. It's rather like someone who has spent his life drawing profiles and who thereby gives everyone the impression that people have only got one eye ... As soon as you realize that, everything is changed. You can't think how much! ... I was especially taken by the possibility of revealing the new space I had discovered: it was an enthusiasm that became the leading concept of Cubism. Therefore I began painting mainly still lifes, for with still lifes you have a tangible, even manipulable space. I once wrote somewhere else: "If a still life can't be grasped in the hand, then it's no longer a still life". That accorded with my constant desire not only to see but to grasp things. I was especially taken by this space for it was the first Cubist picture, the exploration of space. Colour didn't play a very big part. The only aspect of colour that interested us was light. Light and space are two very closely linked elements, and we brought them right together ... They said we were abstract' (Braque, *Vom Geheimnis*, *op. cit.*, p. 17).

The jury of the Salon d'Automne, to which Matisse, Rouault and Marquet, among others, belonged, rejected a selection of Braque's L'Estaque pictures in September 1908. So he exhibited them together with

13 Georges Braque
Woman in an Armchair (Woman Reading), **1911**
Oil on canvas, 128×81 cm
Basle, Private Collection

45

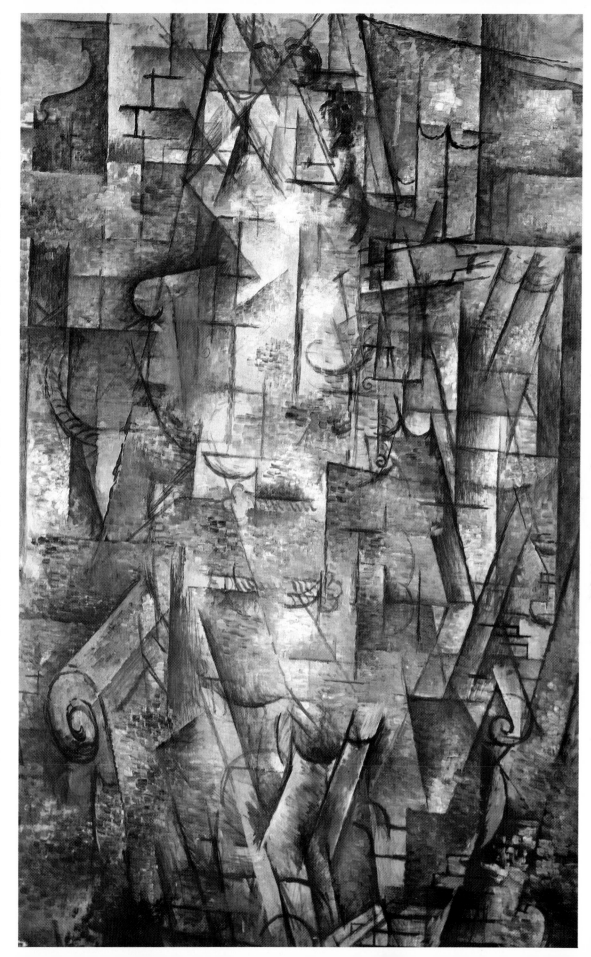

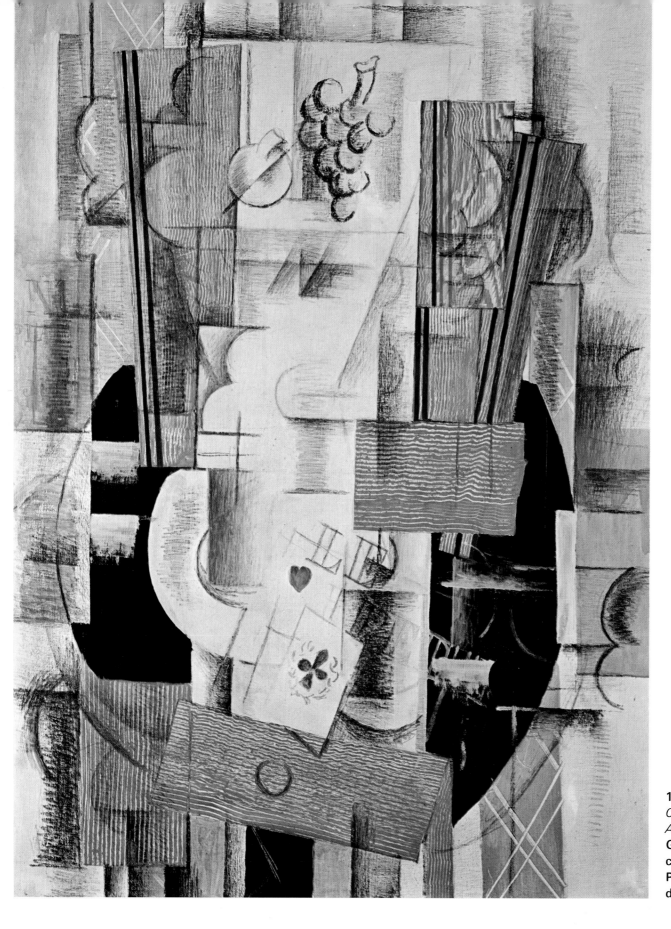

14 Georges Braque
*Composition with
Aces*, **1913**
**Gouache and charcoal on
canvas, 80×59 cm
Paris, Musée National
d'Art Moderne** 46

some others at the Galerie Kahnweiler. The critic L. Vauxelles wrote of the exhibition in *Gil Blas* in November 1908: 'He [Braque] despises organic form and reduces everything—landscapes, figures and houses—to geometrical schemata, to cubes'. This article is said to have given the new tendency its name.

In Braque's *Woman in an Armchair (Woman Reading)* we find the apex of analytical Cubism. Whereas, for instance, in his small still life of 1911, *Glass and Guitar* (Ill. 29, in Braque catalogue) in the Musée des Beaux-Arts at Strasbourg, the glass to the right of centre is a kind of 'guideline' for our perception, so that the spectator measures the entire composition by the depiction of the glass, in our example there is only a slight suggestion of an armchair in the larger arm-rest on the left and the smaller one on the right in the lower part of the painting. In *Violin and Jug* (1910), the painter still distinguished between the entirely illusionistic representation of a nail and its shadow at the top edge of the picture, the imitative depiction of parts of a jug and a violin, and an arrangement of the pictorial elements which is still secondary to the specific composition of the painting in question. In the present case, the non-imitative and non-objective pictorial vocabulary predominates: in a picture presented for contemplation, this vocabulary, in spite of any help offered by the title, is very hard on an eye used to concrete guidelines.

Picasso and Braque tried to counter any threat of the stultification of plastic and colour values by introducing *papiers collés*, or pasted paper, into the composition. This was a major step in the history of artistic collage. The introduction of naturalistic elements into the picture was the first step towards guaranteeing the autonomy of the painting and was followed by such ploys as *trompe l'oeil* fragments (from sawdust, or typographically exact letters from printed alphabets, up to the most varied materials

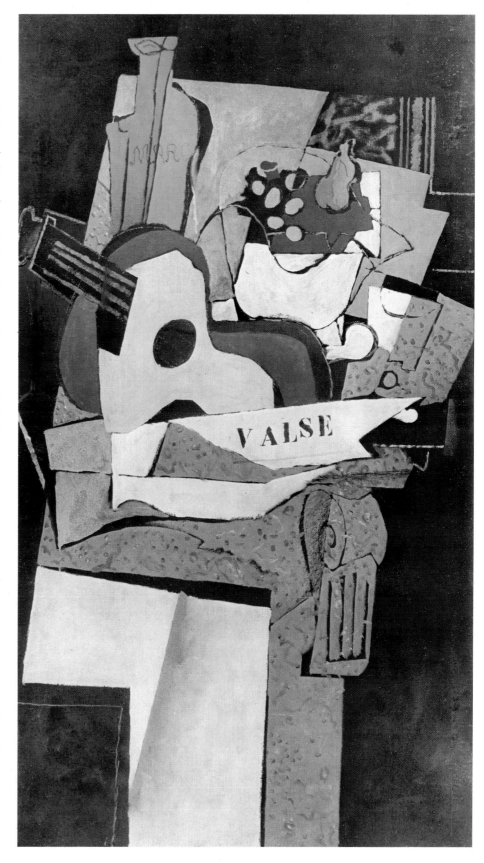

15 Georges Braque
Still Life with Guitar, **1921**
Oil on canvas, 127×72 cm
47 **Prague, National Gallery**

which were at first wholly alien to painting). 'In constant search of reality', said Braque, 'I included letters in my paintings in 1911. They were forms which didn't have to be changed in any way. Letters are flat and therefore stand outside space. If they are present in a picture they make it possible to distinguish the objects within the space from those outside it' (Braque, *Vom Geheimnis, op. cit.*, pp. 18 f).

Through the combination of varied materials and graphic as well as painted areas in the picture, a new entity emerged with a totally distinct reality contained within it (see also Ill. 9). Braque made the first experiment with the new technique in 1912

16 Georges Braque
Still Life (Bowl of Fruit and Table Napkin)
1929. Oil on canvas, 26.5×41 cm
Stuttgart, Staatsgalerie

in his *The Bowl of Fruit* (Ill. 33 in Braque catalogue), a charcoal drawing with *papier collé* on paper. In the upper section, very much as in our example *Composition with Aces*, a bunch of grapes has been drawn in charcoal and the outline of an apple sketched in. Braque's *Bowl of Fruit* marked the beginning of the so-called synthetic phase of Cubism in his work. The artist himself wrote: 'The *papier collé* technique enabled me to make a sharp distinction between colour and form, so that each element became autonomous. That was the great discovery. Colour and form take simultaneous effect on the eye but have nothing to do with one another'.

Braque's creations are often so compelling optically and so finely balanced in composition and tonality—*Still life with Guitar* (Ill. 15) is almost entirely a symphony in grey—that extreme demands are made on the spectator's visual sensibility. In his *The*

Painter of Cubism, Apollinaire honoured Braque's creative power in words that only a friend and a poet could have written: 'That is George Braque. His achievement has been heroic. His art evokes our wonder and astonishment. He is eminently serious. He presents beauty of great delicacy, and the mother-of-pearl brilliancy of his paintings illumines our feeling for them. He has taught men and other painters a form of intercourse with the beauty of unknown forms as only a few poets before had thought possible'.

Gris may be called the theoretician and advocate of Cubism. In addition to his considerable activity as a painter—including work for the Diaghilev Ballet in Monte Carlo and various illustrations for literary works—he defended the artistic theories of Cubism in lectures and essays. The unity of his work is in accordance with the decisiveness of his opinions. Gris' first oil painting and his first Cubist works date from the year 1911. In 1911–1912 he painted the *Portrait of Picasso* that he entitled *Homage to Picasso*. He awakened great interest at the Salon des Indépendants in 1912 with three paintings, among them the Picasso portrait. In 1912 Gris made his first experiments with collages and entered into a contract with Kahnweiler for his entire work. His whole life was marked by poverty and illness. He died at forty. Today Gris is ranked with Picasso (Ill. 4–9), Braque (Ill. 10–16) and Léger (Ill. 23–26) as one of the four great Cubists; this is largely due to Kahnweiler, on whose support the painter could always count.

Gris' oil *The Eggs* is still a painting with a thoroughly traditional style of composition. The table is set back with a sharp diagonal and abruptly shortened by the sides of the painting. A darker dish is pushed towards the foreground of the picture. There are four objects on it and without the help of the title it would be difficult to know that they were eggs. Above the dish there is a huge bottle, half-full of a dark liquid. A white bowl stands at the top left edge of the table, which bisects the left side of the picture exactly. The bowl juts out over the table edge and obscures part of the flower-decorated background. Whereas the bowl directly connects the light table surface with the dark background, the position of the bottle and the dark liquid in it draw the dark brown of the background towards the table. The fact that the flower motif of the decoration on the dish is virtually the same as the pattern in the background confirms the interactions between the various areas of the picture in terms of colour as well as motifs. The diverse relations between the different objects in the painting organize its various areas into one composition and exemplify the Cubist search

17 Juan Gris
Eggs, **1911**
Oil on canvas, 57×38 cm
Stuttgart, Staatsgalerie

for 'more stable factors' that will bind pictorial elements into a significant whole. Unlike the Symbolists, Gris is not concerned with establishing relations between figures and objects in order to prompt the spectator to interpret the picture in sometimes extravagant ways. He wants to produce optically only those associations that can be used in and for the picture. Therefore he tries to show all objects in the picture as optically comparable with one another, in terms of form and colour. Since the form and colour of

18 Juan Gris
Still Life with Pears, **1913**
Oil on canvas, 54×73 cm
Private Collection

eggs, dish and bowl, as well as bottle and liquid, in spite of their ordinariness, are not directly comparable, artistic techniques other than imitation are needed in order to give the various objects appropriately similar forms.

We can find the key to Gris' method (which distinguishes him from Picasso [Ill. 4–9] and Braque [Ill. 10–16], as well as from Léger [Ill. 23–26]) in his drawings which are usually charcoal or pencil works. Like these drawings, for example, *Kettle* (1911) or *Coffee Jug* (1911), the picture shown here—*Eggs*—immediately reveals the painter's wish to avoid hard or sharp angular motifs and to favour soft forms which at most approximate the angular. For example,

the dish with the four eggs on it is an irregular oval delimited to the left by forms which we may interpret as shadows which are both round and angular. The same is true of the left edge of the table, which arches slightly as it approaches the left-hand side of the painting.

The balance and interplay of angular and round forms is repeated in the shape of the objects in the picture: in the four eggs, which, from the point of view of imitative painting, are not eggs at all, in the shape of the bowl to the left of the bottle, and in the presentation of the bottle itself, in which the liquid seems almost pointed. An optical relationship is established which extends even to the muted colour, and is to be seen in

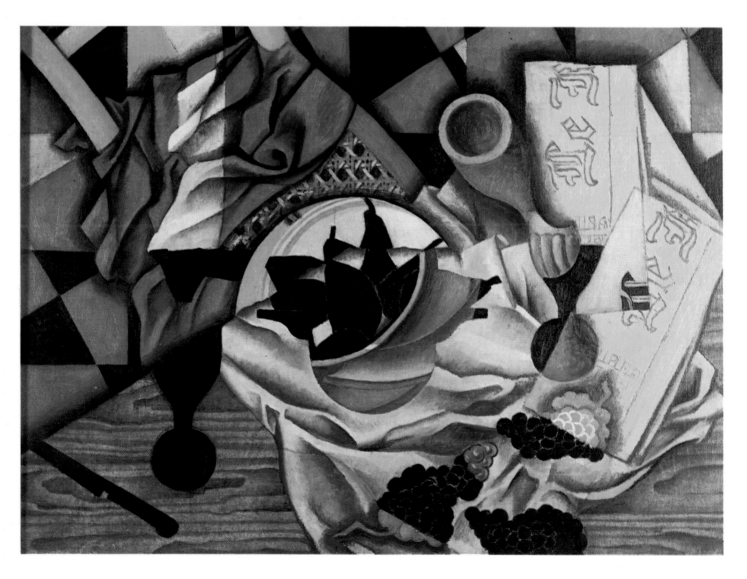

the permanent interchange between the contrast and interaction of colour and form. In this regard the spectator soon notices—to put it somewhat paradoxically—how round-angular or angular-round forms and parts are used to depict the subject.

Gris emphasizes his technique of optical comparison when he alters the distinctive characteristics of as many objects as possible in the picture, in order to unite them as successfully as possible within it. In the visible world things are most often thought of as visual when we look at them from a distance; Gris changes the characteristics of the objective content of the visible world to primarily surface-orientated formal features, yet never forgets his injunction about their tangibility. In this way, visually apprehensible things from the natural world lose their characteristic features, so that they appear on the surface as tangible things which have to be presented in an optically appropriate way. For instance, the painter may combine essentially flat areas with more or less curvilinear areas in such a way that the objects appear increasingly tangible: as if, indeed, they were gradually shaping themselves to accord with a hand reaching out towards them, and their respective volumes depended on that alone. This technique tends, however, to turn objects into pictorial elements 'pure and simple', as is particularly clear in the famous *Still Life With Bottles and Knives*, where the objects do not really belong on a table but declare their autonomy in and as painting. Gris developed his Cubist 'colour-area architecture' beyond the stage of a new interpretation of the conventional characteristics of eggs, plates, bottles and bowls, into specific characteristics of the tangible and manipulable. Those among his works that are wholly in this latter category may be classed among the products of synthetic Cubism, and the remaining paintings

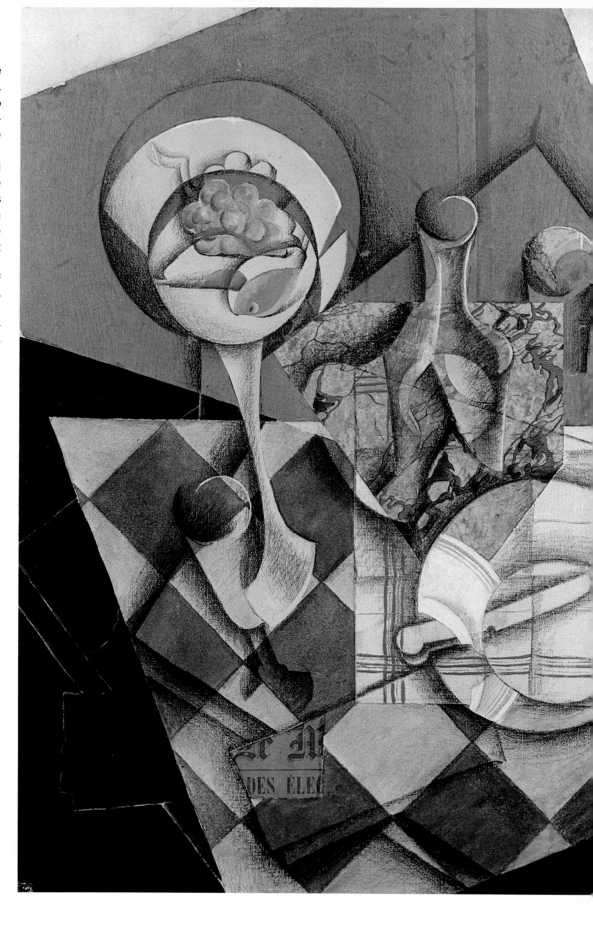

19 Juan Gris
Bowl of Fruit and Carafe, **1914**
Oil, charcoal, pasted paper on canvas,
92×73 cm
51 **Otterlo, Rijksmuseum Kröller-Müller**

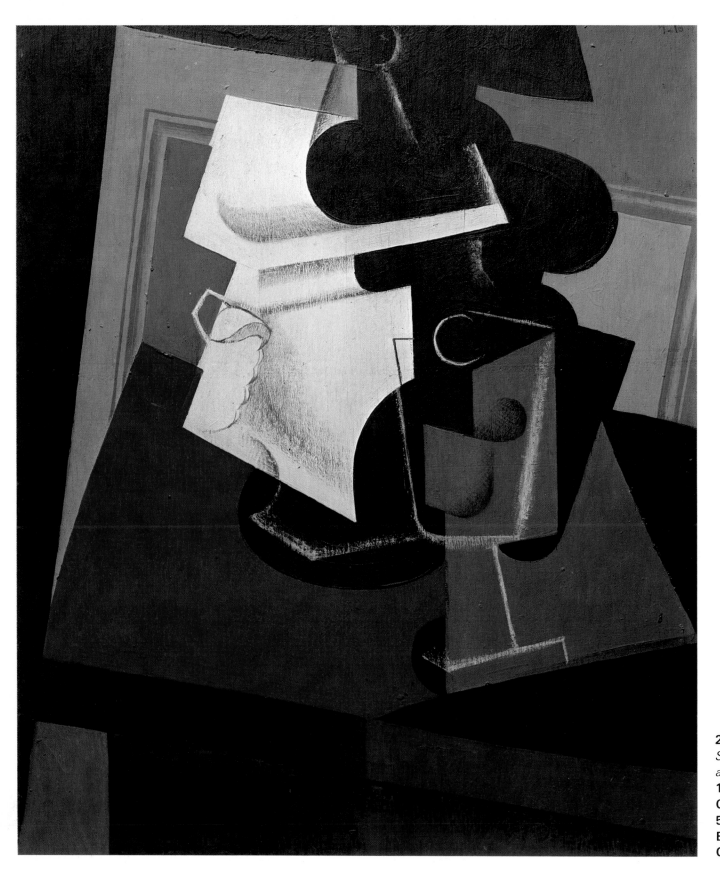

20 Juan Gris
*Still Life on
a Table*,
1916
Oil on canvas,
55×46 cm
Belp, Rolf Büri
Collection 52

by Gris discussed and illustrated here date from that period.

Gris produced a total of seventy-one black-and-white illustrations for José Santos Chocanos' book of verse *Alma América*, which appeared in Madrid in 1906. These are not the only examples of his work which show how related his technique was to the Art Nouveau of the turn of the century. This relationship—it would be wrong to say that his work was *dependent* on Art Nouveau—was hardly alluded to by Kahnweiler in his biography of Gris, although Gris himself called painting 'textural'. Gris' *Still Life on a Table*, *Still Life with Dice* and *Pierrot* are obviously influenced by the major Art Nouveau assertion that, in addition to its own silhouette represented on the surface, the painted object 'describes a reversed form which follows its own exactly, and that this negative form is just as important as that of the object itself' (H. van de Velde). Gris used this discovery and constructed his pictures by means of subtle similarities which are responsible for their impressive classical balance. He sometimes builds up a pattern of relations between positive and negative forms, whereas on other occasions he concentrates on the relations among positive or those among negative forms respectively.

This advance opened the way for a pictorial demonstration of all the richly complex interactions of pictural 'objects'. In the artist's own words: 'I work with the elements of the intellect, with the imagination. I try to make concrete that which is abstract. I proceed from the general to the particular; by which I mean that I start with an abstraction in order to arrive at a true fact. Mine is an art of synthesis, of deduction, as Raynal has said. I want to endow the elements I use with a new quality; starting from general types I want to construct particular individuals. I consider that the architectural element in painting is mathematics, the abstract side; I want to humanize it. Cézanne turns a bottle into a cylinder, but I begin with a cylinder and create an individual of a special type: I make a bottle—a particular bottle—out of a cylinder. Cézanne tends towards architecture, I tend away from it. That is why I compose with abstractions (colours) and

make my adjustments when these colours have assumed the form of objects. For example, I make a composition with a white and a black, and make adjustments when the white has become a paper and the black a shadow: what I mean is that I adjust the white so that it becomes a paper and the

21 Juan Gris
Pierrot, **1919**
Oil on canvas, 90×70 cm
Paris, Musée National d'Art Moderne

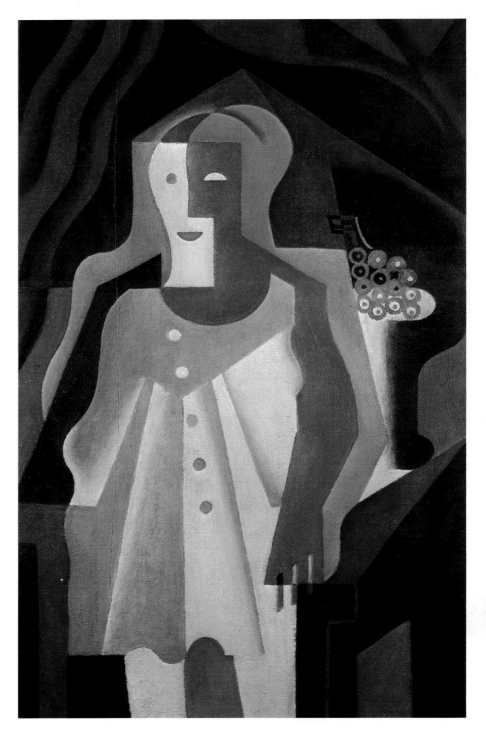

53

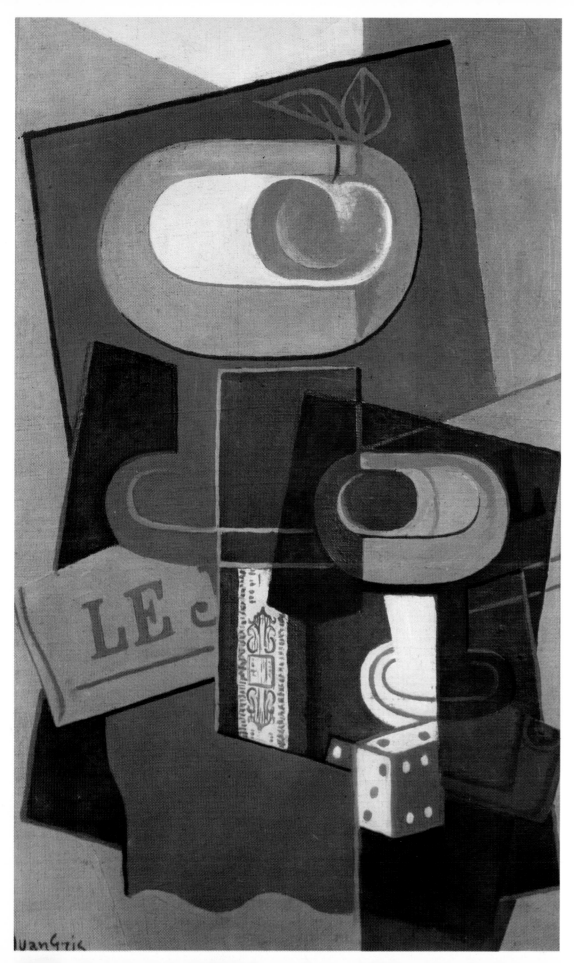

black so that it becomes a shadow. This painting is to the other as poetry is to prose' (D.-H. Kahnweiler, *Juan Gris, his Life and Work*, London, 1947, p. 138).

Léger produced not only paintings but stage and film designs and murals: for instance, for the L'Esprit Nouveau pavilion (with Le Corbusier), and one in the Léger Museum at Biot near Cagnes. During his years in the USA (1940–1945), when he had a Chair at Yale, Légelr designed murals for various places including the Rockefeller Centre.

The Normandy-born Léger at first experimented with painting, like many others. Only after the great impression which the Cézanne memorial exhibition in the 1907 Salon d'Automne made on him, and the concurrent show of Cézanne's watercolours at the Galerie Bernheim-Jeune, did his ideas and intentions in art become more precise. In 1910 Léger was discovered by Kahnweiler. He made his breakthrough in 1911 when he submitted a total of five pictures to the exhibition at the Salon des Indépendants, among them the oil *Nudes in a Landscape* of 1909–1910 (col. plate 86 in Cooper, *op. cit.*), which is now in the Rijksmuseum Kröller-Müller at Otterlo. The painting has a naturalistic base in its depiction of woodcutters at work—a motif that Léger translates into his spare version of Cubism. Similarly to Malevich's *The Woodcutter* (Ill. 43), all the objects portrayed are interpreted in the new way. But Léger elucidates and

22 Juan Gris
Still Life with Dice, **1922**
Oil on canvas, 59.5×36 cm
Paris, Musée National d'Art Moderne 54

unifies the picture largely by restricting himself as far as possible to only *one* fundamental stereometric form, the cylinder—in the form of the tubes which later recurred frequently as major elements in his paintings, for instance in *Two Women with Still Life.* 'I did my best to get away from Impressionism', said Léger later, 'I was possessed by an idea: I wanted to dislocate the bodies. They called me a "tubist", didn't they? Sometimes I lost heart. I spent two years working on the volumes of *Nudes in a Landscape*, which was finished in 1910. I wanted to bring out the volumes as much as possible ... For me *Nudes in a Landscape* was a battle of the volumes ... volume was enough for me'.

Léger's *The Wedding* belongs to the same series as *The Smoker* (1911) and the oil sketch for *Woman in Blue* (1912). In these works the painter tries to mediate between the emphatically static composition of Picasso's and Braque's Cubism and the more dynamic aspects that were emerging from the development of Cubism. He uses the vertical structure of the tall picture to help in this process.

When faced with *The Wedding*, one is more troubled than might be the case with other pictures of this kind by the interchange between large forms picked out in bright individual colours and very small ones, which essentially follow the 'tubist' pattern Léger had laid down in *Nudes in a Landscape*. Whereas the areas of the picture featuring the smaller forms are more objective, it can hardly be said that the larger forms any longer refer to anything outside the picture. In another sense, the smaller, more detailed areas of the picture largely consist of parts and fragments of figures, among which the bent tubular hands and angular arms play a major part optically. These individual parts assert their independence as objects with their own force, so that the observer is hardly tempted to try, as in a puzzle, to put the parts together again. If he wishes to discover the meaning of the title in relation to the picture, it is not too difficult to interpret the rhythmic vertical and horizontal patterns of the picture by the repetition of similar and like forms, as the representation of festivity, such as one

might meet with at a country wedding, but without any use of imitative techniques. The larger areas act as pictorially-specific signs which do not refer to any model outside the picture, whereas the figurative parts follow the stereometric form of the cylinder.

The title assists the process of combination and organization into an optical whole, which then becomes the optical 'meaning' of the concept. It is clear, however, that this form of construction is just as suitable for a pictorial version of a quite different situation.

The picture's restriction to a single basic stereometric form causes the painting's random perspective to stand out as boldly as the optical. On the other hand, every single piece of 'tubing' is given a specific objective and autonomous character. This is as true of the portrait of Léger's mother, *Woman Sewing* of 1909, as of our example, *Contrasted Forms.* This objective structura-

23 Fernand Léger
The Wedding, 1910/11
Oil on canvas, 275×206 cm
Paris, Musée National d'Art Moderne

24 Fernand Léger
Contrast of Forms, **1913**
Oil on canvas, 100×81 cm
Paris,
Musée National
d'Art Moderne 56

25 Fernand Léger
Signal Disks, 1918
Oil on canvas,
240×180 cm
Paris, Musée
d'Art Moderne
57 de la Ville de Paris

tion by means of tubular elements and parts became for Léger a specific way of understanding objects; everything that could be distinguished pictorially was allowed its own specific objective, or 'thing-like' appearance—landscapes and machines just as much as human beings or parts of them. All non-objective parts of the picture (as in *Signal Disks*) are included in this treatment, so that the best of Léger's works offer a successful optical synthesis of the inorganic, organic and technico-artistic. He clearly shows the spectator that all things, whether natural or manufactured, are objects in their own right—a stone, a bridge-support, or a human arm. Léger shows in his paintings that the objective is itself an object of painting. He wished to get away from the idea of the picture as an imitation, a copy of a landscape, a still life or a human face, and to replace it with the artist's picture as an artifact that was itself an object—an 'object-picture', a 'picture-object' (Léger) and a beautiful object, yet a self-sufficient image. In this sense, Léger declared: 'The object should play the main rôle in contemporary painting, and suppress the theme. When people, figures and the human body become objects, there is great freedom ... But if the human body is still given a sentimental or expressive value in a picture, no development is possible in figure paintings. A cloud, a machine and a tree are elements of the same interest as people or figures'.

26 Fernand Léger
Two Women with Still Life, **1920**
Oil on canvas, 73×92 cm
Wuppertal, Von-der-Heydt Museum

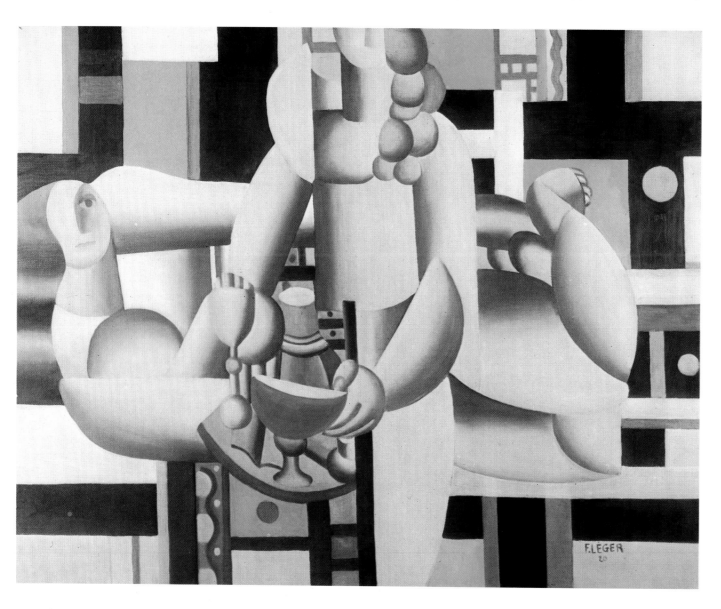

Like Cézanne (Ill. 1–3) in his painting based on the disposition of colour, Robert **Delaunay** did not start from line, outline and linear delimitation as means of representation, but mainly from colour. He wanted to use the pure colour of the spectrum in a way appropriate to two-dimensional painting, presenting colours in their essential characteristics and qualities so that they enabled the spectator to see independently, and without associations and interpretations. In his search for solutions to the problem of colour application, Delaunay rejected pure imitation and tried to adapt to Cubist notions. By way of scientific colour theory, for instance that of the Frenchman Chevreul, he arrived at a form of concrete or abstract art, which presents optically only what is within the capability of the means of painting—its production, arrangement and organization on the picture surface. Hence, instead of object-colour or precise local colour, the artist makes superficial colour a major aim and produces an interaction of bright areas of colour.

Delaunay liked painting the Eiffel Tower, which was then a rather odd theme for a painter. He returned to the circular shape despised by painters for centuries. Even though he sometimes was classed as a sub-Cubist, Delaunay really belonged to no school. Any of his famous series of *St Séverin*, *Cities* or *Window* paintings reveal his considerable originality in the combination of colour and form, and show how far he was from being a mere imitator. He produced an extremely versatile, flexible and richly varied artistic instrument in spite of the obvious starting-points in already established practice. Perhaps this is what his poet friend Guillaume Apollinaire referred to when he called Delaunay's painting 'Orphic'.

Tower with Curtains shows how Delaunay made use of Cubist ideas. This is one of his more than thirty views of the Eiffel Tower. The conventional motif of the view from a window is clearly stressed by the curtains on either side and combined with the conventional image of Paris dominating the view, but the means of representation are those established by early Cubism. They are used to show the aggressive aspect of

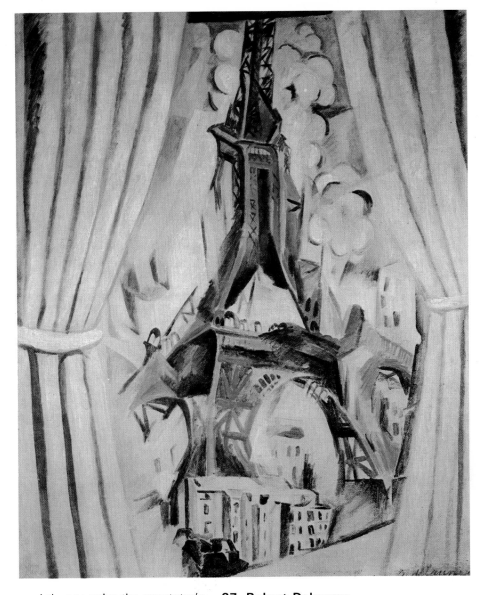

the Tower, and thus to seize the spectator's attention. Parts of the Tower are shown so as to convince the spectator that he is about to see others. What the individual human figure was for Picasso or Braque, the gigantic artifact of the Eiffel Tower is for Delaunay. The colour is muted and uniform and recalls Cubist practice.

Apollinaire wrote on March 19, 1912 of Delaunay's enormous *La Ville de Paris*: 'Delaunay's picture is the most important in the exhibition. *La Ville de Paris* is more than an artistic expression. With this picture an idea is re-established which has probably been lost to view since the great Italian painters' (Delaunay catalogue).

27 Robert Delaunay
Tower with Curtains
(View of the Eiffel Tower), **1910**
Oil on canvas, 116×97 cm
Düsseldorf
Kunstsammlung Nordrhein-Westfalen

The picture entitled *Circular Shapes, Sun, Tower* is an example of the great transition in Delaunay's work. Albert Gleizes (Ill. 40) wrote in an unpublished piece: 'Delaunay has been a revolutionary since the day when, with disarming ignorance, he stopped painting like those about him. That was when he produced his first "circular painting"' (Delaunay catalogue). For Delaunay, the

specific 'language' of painting, which stimulates the eye with pure colour by producing a 'colour conflict' (Imdahl), was colour on the basis of circles, segments and arcs. In this form of colour painting everything circular and semi-circular is especially suitable, because it helps to emphasize the masses of colour and through the apposition of similar part-fields ascribes apparently predetermined places to the colours, withoohout affecting their intimate contact with one another. It also helps to equilibrate the colour structure so that none of the directional values is overemphasized, all possible directions are equally effective, and the colour-forms fit one another perfectly. Hence in this multiple association

28 Robert Delaunay
Paris, **1910/1912**
Oil on canvas, 267×406 cm
Paris, Musée National d'Art Moderne

of circular shapes supporting changing colour effects, the somewhat strident yellow, orange and red bottom left are relieved by various blues, and green which is complementary to red. The colours interact uniformly through their associations and oppositions because they are appreciated simultaneously by the spectator's eye. Delaunay said of the development of his work towards pure colour-objects: '... Colour has to be developed in its own right but not as coloration (objective forms). My studies began with the observation of the action of light on objects, which led to the discovery that the line did not exist in the sense of the old rules of painting; it was deformed and broken by rays of light. It was a continuous study of form expressed in light or, rather, in lights; in other words, the colours of the spectrum, by simultaneous contrast. I dared to produce an architecture

of colours in the hope of creating the elements of a dynamic poetry, while remaining within the bounds of pictorial means, without using literature or descriptive anecdotes. I arrived at a form of abstract Cubism, in which colours interact through the development of their contrasts, but are still related to objective signs and symbols'.

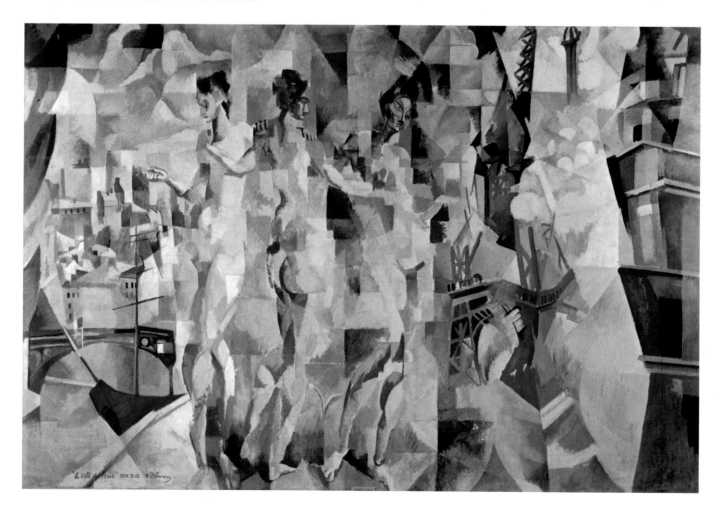

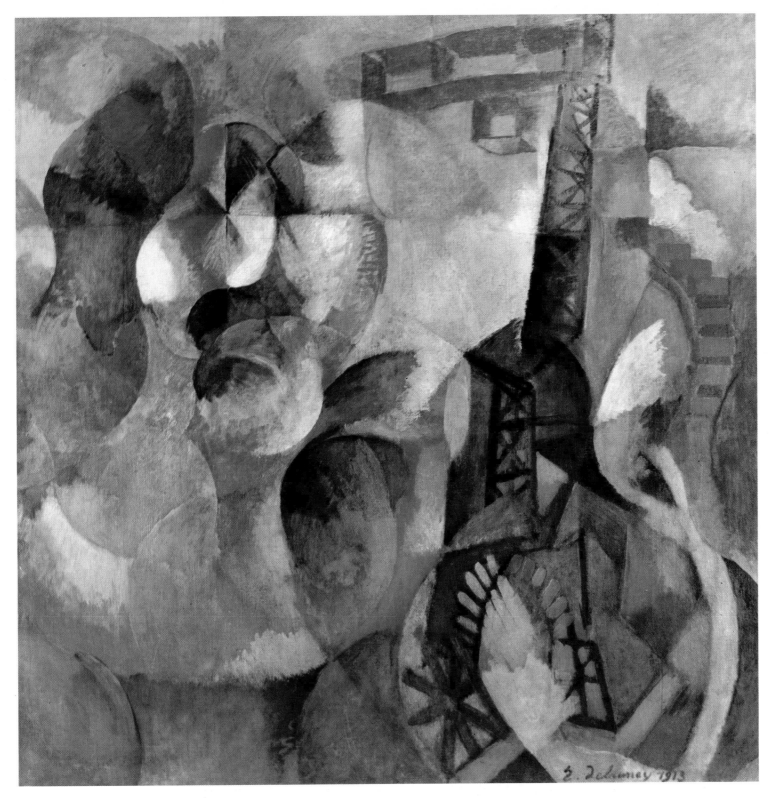

29 Robert Delaunay
Circular Shapes, Sun, Tower, **1913**
Oil on canvas, 109.5×89.5 cm
Paris, Private Collection

Sonia **Delaunay-Terk** was born in southern Russia. She was seventeen when she moved to Karlsruhe, Germany, where she studied drawing. Three years later she went to Paris, and enrolled at the Académie de la Palette. She became a friend of the painter and art theorist Ozenfant, who was also studying at the Académie. Ozenfant was interested in the 'purification of plastic language' and the 'classification of colours and forms'. Therefore Delaunay-Terk, whose early works showed her interest mainly in Gauguin, van Gogh and the Fauves, did not find anything strange in the artistic theories of Robert Delaunay, whom she married in 1910. The problem of making light pictorially autonomous, a concern of Delaunay's, also fascinated the Italian Futurist Balla, the Russian Rayonnists (Larionov and Goncharova) and the still obscure Georges Jakulov, who in 1913 stayed with the Delaunays at Louveciennes, where they spent a long time together observing the dissection of sunlight and moonlight in the prism.

The two works of Delaunay-Terk that we illustrate here show on the one hand a form of composition based on the approach worked out by Delaunay; non-objective areas arranged according to the primary colours red, yellow and blue, and the corresponding secondaries orange, green and violet—what the painter Hölzel called the 'countertriad'. 'The pure colours,' wrote Sonia Delaunay-Terk, 'became contrasted areas of paint, and produced for the first time a form which was established not by dark and light but by the depth of the colour relations themselves' (cf. Cabanne, *op. cit.*). Because the picture is restricted to primary and secondary colours, the spectator's eye is persuaded to look at the contrasted colours *through* one another, so that optical compensation and stimulus produce simultaneous colour vision. Delaunay-Terk's paintings represent a version of 'Orphic' painting developed from the ideas of Delaunay himself; she succeeded in organizing the coloured areas—circle, segment, arc, and triangle or rectangle—into a rhythmic and very decorative composition. She did this, for instance, by the interaction and superimposition of circles (as in *Electrical Prisms*), or by emphasizing diagonals from top left to bottom right (as in *Bullier*).

Delaunay-Terk was recognized by more than just her husband and friends. She sent twenty paintings to the first Autumn Salon in Berlin in 1913, among them some of the compositions on silk she had produced since 1912. The more than 350 works by eighty artists from Europe and America included some from Balla (III. 48–50), Boccioni (III. 51–54), Carrà (III. 55–57), and R. Delaunay (III. 27–29), Gleizes (III. 40), Metzinger (III. 41), Mondrian (III. 45), Picabia (III. 32) and Severini (III. 58–60).

In 1913 Delaunay-Terk illustrated a book by the poet Blaise Cendrars—his name is in *Electrical Prisms* to the left below the centre of the picture—with pure, contrasting colours. The book was exhibited in Paris, Berlin, London, New York and St Petersburg, and Robert Delaunay wrote in October 1913: '. . . the simultaneous word . . . leads by way of simultaneous colour and the contrast of simultaneous colours to a new aesthetic representative of our age' (Delaunay, in: Cabanne, *op. cit.*)

30 Sonia Delaunay-Terk
Simultaneous Colours, **1913**
Oil on canvas, 97×139 cm
Bielefeld, Städtisches Kunsthaus

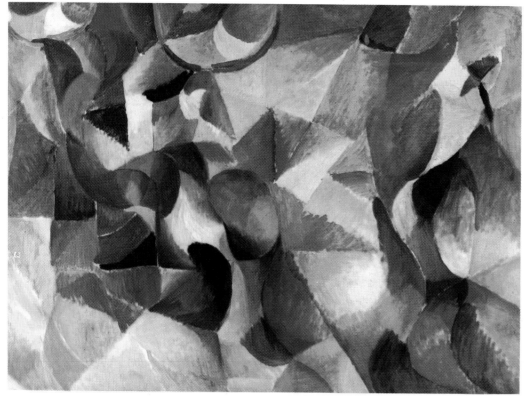

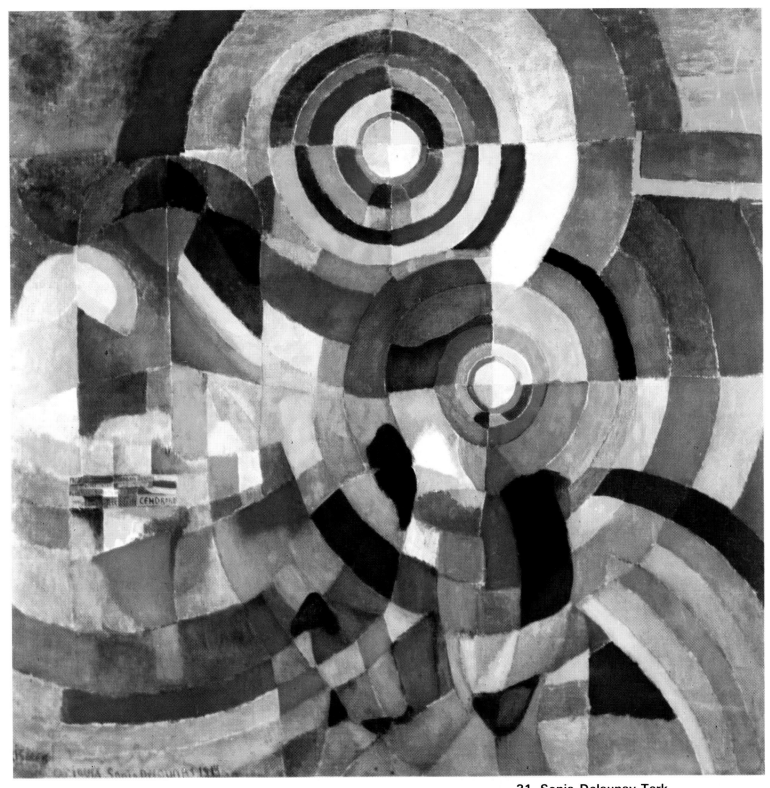

31 Sonia Delaunay-Terk
Electrical Prisms, **1914**
Oil on canvas, 250×250 cm
Paris, Musée National d'Art Moderne

32 Francis Picabia
Udnie, **1913**
Oil on canvas
300×300 cm
Paris
Musée National
d'Art Moderne

Picabia, a Frenchman of Spanish origin, is among those artists who cannot easily be classified. They search restlessly for something new, not so much to identify with a specific movement in art as to influence artistic development in certain ways. After Impressionist beginnings, Picabia produced paintings with Cubist elements from about 1908–1909, but treated the general business of art with considerable scepticism. He was interested in a painting which 'arises from pure sensation and creates the world of forms anew in accordance with its own wishes and ideas' (Picabia, in Cabanne, *op. cit.*). The picture shown here follows this idea most closely: forms of equal value are created by the arrangement and dissection of the pictorial means, in order to show the movement proper to dance and to any figure in motion. The complete absence of imitative details enables the artist to construct autonomous signs for activity and rhythm from angular and curved areas and forms; and to produce a sort of confusion, 64

which gives rise to a continuous emphasis on the flatness of the picture, instability and uncertain spatial distances. Futurist ideas have been influential here, especially Boccioni's (Ill. 51–54), and the representative Futurist exhibition of 1912 in Paris may have contributed to the result. In 1916 Picabia co-founded the Dada movement and took part in its noisy publicity efforts. Yet by 1921 he was to be counted among the Surrealists, such as Masson, Ernst and Dali.

The third example of work by artists who may be counted among Parisian Cubists, who were concerned with the painterly portrayal of movement in space in 'competition' with the cinema and photography, is *Troops on the March* by **Villon**, the elder brother of Marcel Duchamp (Fig. 39). Villon had painted his most famous work by 1912.

The colour is very muted in relation to the linear structure of the picture, which becomes dominant. If, as usual, we begin to look at the picture from left to right, we see a soldier near the left-hand edge of the painting, though he is only lightly sketched in. He seems to march away from the spectator and towards the centre of the picture. This impression is supported by a number of small helmeted heads. So far the work is still essentially imitative, but this element is contrasted with the free linear structure of the painting seen as a combination of small, broad, dots and lines, which sharply divide or finely, almost web-like, intersect here and there, and with the light shiny colour which is accentuated at certain points by a few dark areas. Beginning with the marching soldier on the left, Villon has tried to give the impression of a few soldiers on the march.

The technique he has used to make this marching apparent derives from a number of diagrammatic sketches of movement after chronophotographs. These were known from the work of E. J. Marey, which was also an influence on Duchamp's *Nude Descending a Staircase* (Ill. 39). Marey called them 'Photogrammes géometriques'. The diagrams rely on a very highly-differentiated structure of intersecting and interpenetrating lines, which can scarcely be interpreted in any meaningful way, without a photographic original. Like Expressionism, Cubism was not a unified, let alone uniform, movement in painting at the beginning of the twentieth century. But the invention of Cubist forms influenced various leading artists, even when they were aiming at diverse goals.

33
Jacques Villon
Troops on the march, **1913**
Oil on canvas,
65×92 cm
Paris,
Musée National
d'Art Moderne

In 1911 R. and M. Duchamp (Ill. 39), the painters Gleizes (Ill. 40), Kupka (Ill. 36, 37), Léger (Ill. 23, 26), Picabia (Ill. 32) and others met at the house of J. Villon (Ill. 33) and his brothers. Among these artists was **La Fresnaye**. He had studied at the Académie Julian and the Académie des Beaux-Arts. In 1908 he was a pupil of the painters M. Denis (one of the Nabis) and P. Sérusier at the Académie Ranson. La Fresnaye was an aristocrat from an old Norman family—one

of his ancestors wrote a famous *Ars poetica* in the sixteenth century. He had studied mathematics before taking up painting, and he interested himself mainly in the constructional potential of the new discoveries. In his painting *The Conquest of the Air* and the example shown here, in addition to the representational and geometrical technique of early Cubism, he tried to establish a Cubist perspective in the general aspect of the figure by means of position and attitude, and by such devices as geometrical dissection of the face, in order to balance the largely non-objective forms around the figure. The muted colour is nevertheless related to the actual colours of the objects depicted. La Fresnaye,

who looked on the artistic means developed by the Cubists as 'a collection of mere constructional tools', said of this development: 'Since the painting of our own days is unable to rival that of the past, it uses its own unconventional means in an attempt to escape the dilemma' (cf. Cabanne, *op. cit.*).

34 Roger de la Fresnaye
Man Sitting (The Architect), **1913**
Oil on canvas, 130×165 cm
Paris, Musée National d'Art Moderne

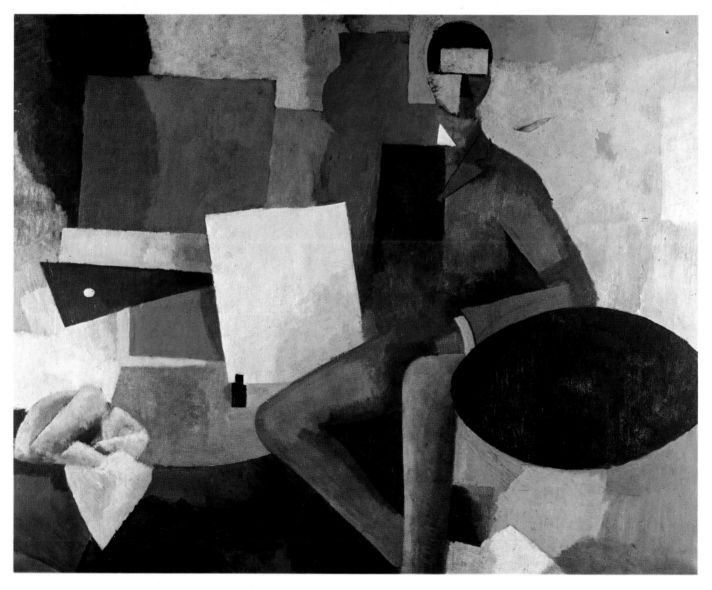

Louis Markus, a Pole who had been in Paris since 1903, changed his name to **Marcoussis** (after a place-name in the Seine-et-Oise Département of France) after his first meeting with the poet and art critic Apollinaire. Like most of the artists who are thought of as Cubists, he began painting under the influence of the formal colour techniques of the post-Impressionists. For financial reasons, Marcoussis stopped painting between 1907 and 1910 and tried to earn a living drawing caricatures for various papers and magazines. It was Apollinaire who introduced him to Picasso and Braque in 1910. Marcoussis began to paint again and concentrated on landscapes and still lifes.

The thematic framework of a Cubist picture is there in our example, *Still Life with Chessboard*: simple objects from everyday life—a carafe, a glass, matches, a pipe, an ink-bottle, an envelope, playing-cards, a chessboard, letters of the alphabet, numbers. Yet the various objects are not so much composed in accordance with Cubist practice and in relation to one another, as combined and related 'additively' like the squares of the chessboard. The superimpositions partly serve to keep them together, partly ensure however that the picture develops optically on several levels and that the individual areas incline variously towards the surface; this accentuates the aspect of transparency or penetrability given by the tendency of the tonality towards a single colour (its darkest points are the linear markings). The treatment of colour and form shows evidence of an almost 'glassy' transparency which makes possible a recession of various levels in the picture and recalls Marcoussis' glass paintings (for instance, *Still Life* of 1920). The division of the picture increases towards the centre and serves to isolate the objects and make them look as if they were distributed arbitrarily. The divisiveness is arrested and optically organized by the pattern of the chessboard. The angular areas of the chessboard lead the eye directly to the large number of polygonal objects and other elements which cannot be identified as objects. Only now is the spectator aware of the few objects with round outlines which are distributed over the entire inner surface of the painting and simultaneously respond to and oppose the often long straight lines of the composition.

35 Louis Marcoussis
Still Life with Chess Board, **1912**
Oil on canvas, 104.5×84.5 cm
Paris,
Musée National d'Art Moderne

67

Kupka can hardly be called a Cubist in the strict sense. After Symbolist beginnings, he passed by way of neo-Impressionism and a kind of Fauvism to the representation of movement in spatial sequence, and to the use of colour gradations to organize the composition; these were divided either vertically or in circles, and took Kupka towards his own form of non-objective, abstract painting.

Kupka is not, like Duchamp (Ill. 39) interested in the chronophotographic analysis of movement in which different stages of a movement are arrested optically; nor, like the Futurists in their earlier stages,

36 Frantisek Kupka
Newtonian Colour Disks, **1911/1912**
Oil on canvas, 49.5×67 cm
Paris, Musée National d'Art Moderne

in using an essentially naturalistic basis (for example, a figure, a horse, or a motor car). In accordance with his intention to paint 'pure movement' and nothing else, in *Vertical Areas I* and in *Newtonian Disks* he employs means without any antecedent naturalistic burden, ideal objects such as rectangles and circles. He uses abstract means, here, for the concrete theme of 'movement', in order to evoke a comprehension of movement in the spectator and keep him from thematic suggestion. Not only the theme but the means, the rectangle and circle, are concrete. Their form of presentation is a rectangle or circle, so that it is possible with such objects to demonstrate and exemplify rather than imitate or reproduce. In the paintings shown here, Kupka is not trying to use a rectangle and a circle to portray, for

example, a house or a human face. Instead he wants to 'say': Look at the arrangement, sequence and characteristics of my geometrical figures in this painting!

Vertical Areas I was one of the artist's first abstract paintings in this sense, and is intended to show movement as a process in which there is a displacement from place A to place B and perhaps, then, to place C.

We see thin, vertically-positioned rectangles on a roughly painted greenish-blue background, which is as important in the composition as the geometrical shapes and can hardly be called a background. The relative positions of the shapes make them look as if they were slowly emerging from a point top left or disappearing in that direction. The movement is arrested at the foremost dark-blue rectangle, where the

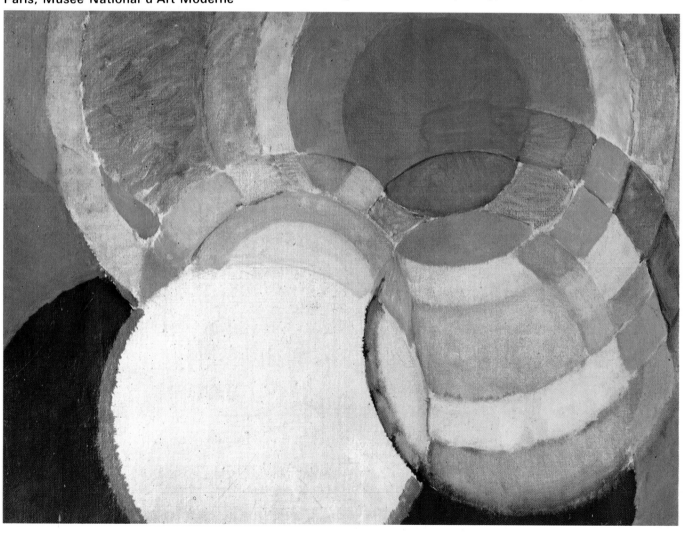

disappearing process has its starting-point, or the approaching movement reaches the point closest to the spectator. The very intense colour contrast of blue, black and white is also a transitional point from which the movement to the right and out of the picture proceeds, or the reverse. The emphasized verticality of the static visual elements means that one has to speak, given the simultaneity of vision, somewhat paradoxically of a 'stabile mobile'. Kupka himself said: 'In order to give an impression of movement with static means . . . one has to present a sequence of images. In order to do that in the visual arts one must offer a series of variously intense images, from the visually less perceptible to the very perceptible. . . . In this way one gives the impression of continuous movement, especially if the images are cinematically multiplied, and move from degree to degree, from level to level'.

In *Newtonian Disks* Kupka is interested in the phenomenon of rotation on the spot. The eye is led from the darker red circles (top right) to the light, almost uniformly greyish-white disk (bottom left). A rotatory movement parallel to the picture surface may be observed, because the faster a colour disk rotates, the more a light haze develops and it loses its colour. The circular shape to the right of the light disk seems to induce a quick rotation into the depths of the picture, its axis being parallel to the picture and slightly to the left. The brightly-coloured areas of the sphere are transformed with increasing speed into strips of minimal colour contrast, which is only perceptible when the rotation is so to speak arrested at its climax.

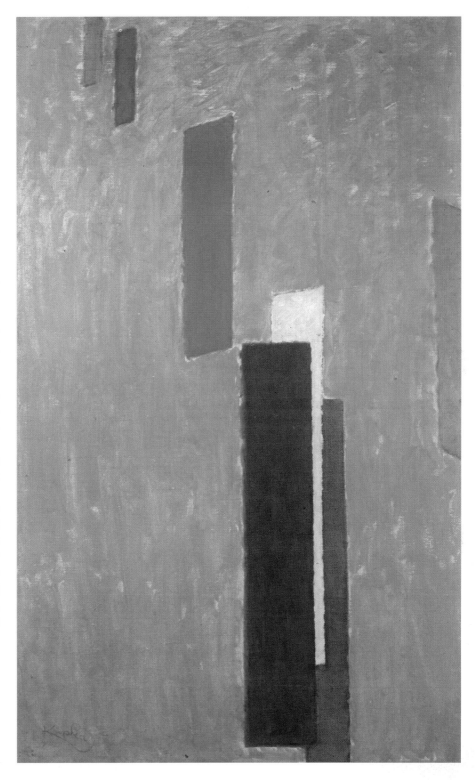

37 **Frantisek Kupka**
Vertical Surfaces I, **1912**
Oil on canvas, 152×94 cm
Paris, Musée National d'Art Moderne

Derain was one of the artists who gathered round Matisse and showed their new ideas to the public for the first time at the Salon d'Automne in 1905. These artists were called 'Fauves', or 'wild', on account of their disregard for the actual colour of the objects depicted and the generally free, often spontaneous use of bright, unmixed colour

38 André Derain
Still Life on a Table, **1910**
Oil on canvas, 92×65 cm
Paris, Musée National d'Art Moderne

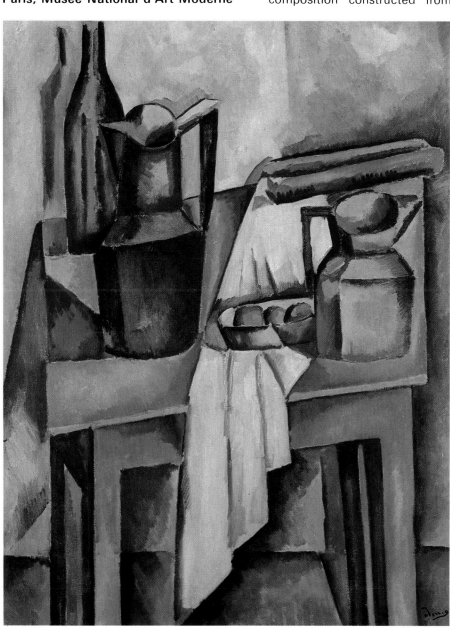

without caring for academic rules and cautions. The public found the pictures of the main members of the group, Matisse, van Dongen, Vlaminck and Derain, 'monstrous' and 'strident with red and blue, bisected by heavy lines'.

The individual members of the group soon began to go their own artistic ways. Influenced by Picasso, whose friend he had been since 1906, Derain's pictures around 1906–1907 (for example *The Street, Landscape near Cassis*, 1907) feature a composition constructed from simplified forms and emphatic contours. Derain's pictures, as our example *Still Life on a Table* shows, contained obvious Cubist elements, but his method always relied on whatever Picasso or Braque had discovered and never went beyond them. Under the influence of Picasso and Braque, around 1908 Derain abandoned the singing colour of the Fauves in favour of more muted, cooler colours.

Still Life on a Table is among his most important works and relies on early Cubist techniques. Like Braque in *Houses at L'Estaque* (Ill. 12) or Gris in *Still Life on a Table* (Ill. 20) the artist chose a viewpoint that would allow an organization based less on perspective than on the surface of the canvas. The emphasis on vertical direction and diagonals that are almost horizontals, affords a stable composition which stressed the static effect. The objects depicted are reduced to basic geometrical and stereometrical forms and adapted to the static composition so that the individual forms become comparable with one another. On the basis of an imitative representation of objects on a table, the painter offers a composition oriented to the surface. In it the change from frontal viewpoint to viewpoint from above (as with the jugs), plays only a subordinate role in regard to the individual objects. The work as a whole cannot escape a strong inclination towards Cézanne's painting, especially his still lifes.

Derain did not follow the further development of analytical and synthetic Cubism. From about 1912 he produced mainly figure paintings in a stylized neo-classical manner. Later he spent much time in studying the old masters, for example Giorgione and Poussin, and the Impressionists, especially Renoir.

After Derain's death thirty-seven of his mask-like clay-sculptures were discovered and cast in bronze.

The works of **Duchamp**, Kupka (III, 36, 37) and Villon (III. 33) are very closely connected in artistic technique and theme. That may seem surprising at first. Yet all three tried to use visual elements in order to depict movement, as had been done in photography and the cinema (which was only just then becoming more than a scientific curiosity or plaything) while adhering to the traditional medium of painting.

The painting *Nude Descending a Staircase II* is one of an entire series of Duchamps between September 1911 and May 1912, whose main theme is movement pure and simple. The picture shows a figure so to speak quintupled. The rhythmic staggering of the figure to bottom right starts at top left. The left-right diagonal determines the picture and makes it impossible to 'read' in the usual way from bottom left. On the other hand, the spectator's viewpoint is fixed at bottom left, for the various positions of the figure are gradually shown to be observed from below. In opposition to Cubist ideas, the principle of perspective is essentially quite traditional. From the spectator's viewpoint, the figure is designed to draw close at first, then to turn to the right and to pass by the spectator. The fluidity of the scene is ensured by the loose repetition of small thin areas and by the use of muted yellow-greenish-brown tone, occasionally heightened with white; these are of course not imitative but representational techniques. Whether the figure actually is nude is of secondary importance. Duchamp himself said that it represented the act of walking in a kind of street scene, as far as the static easel painting allowed reproduction of the paradox of simultaneity in a chronological sequence. Duchamp later acknowledged his indebtedness to the 'stroboscopic' pictures made famous by E. J. Marey.

Right:
39 Marcel Duchamp
Nude Descending a Staircase, II,
1911/1912
Oil on canvas, 147.5×89 cm
71 **Philadelphia, Philadelphia Museum of Art**

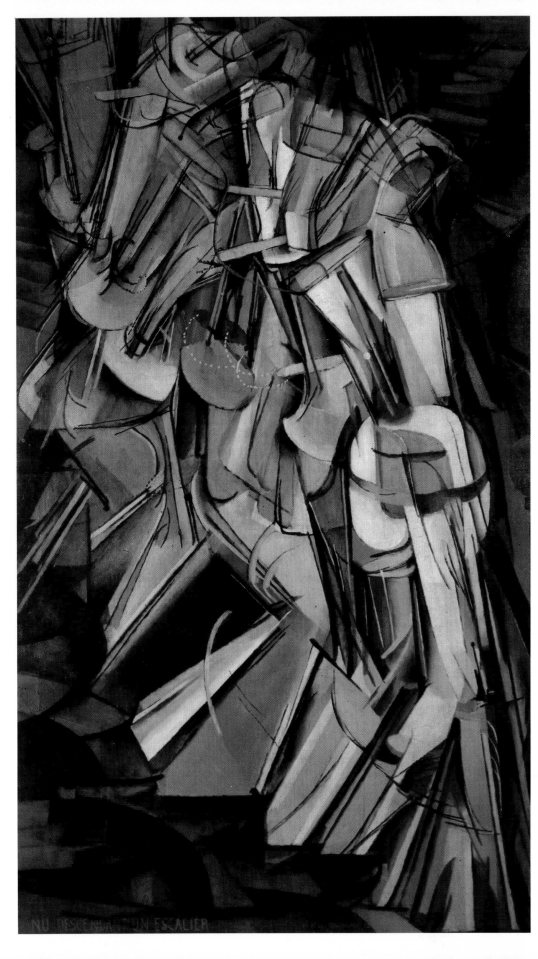

40 Albert Gleizes
Landscape near Montreuil, **1914**
Oil on canvas,
73×92.5 cm
Saarbrücken,
Saarlandmuseum
(Gallery of Modern Art)

By 1913 translations had appeared in London and Moscow of the book written and published in Paris in 1912 by Gleizes and Metzinger (III. 41): *Du Cubisme*. A long excerpt was also published in Prague. The German translation was published as a Bauhaus book in 1928, and a new edition was issued in 1947 with original graphics by Gleizes and Metzinger themselves, and by Duchamp (III. 39), Picabia (III. 32), Picasso (III. 4–9), Villon (III. 33), and so on. The basic theses of the book are partly uncompromising and almost orthodox in presentation; among them is an injunction on the indebtedness of Cubism to Cézanne: 'To understand Cézanne is to foresee Cubism',

the notion of autonomous artistic media applied with an anti-decorative intention, and the consequent 'right to existence' of the painting as an autonomous 'organism'. 'Let the picture imitate nothing; let it nakedly present its motif, and we would indeed be ungrateful were we to deplore the absence of all those things—flowers, or landscape, or faces—whose mere reflection it might have been. Nevertheless, let us admit that the reminiscence of natural forms cannot be absolutely banished—as yet, at all events. A form of art cannot be raised to the level of a pure effusion at the first step' (Gleizes/Metzinger, *Cubism, op. cit.*).

Gleizes in fact never relinquished the

portrayal of human beings and their surroundings. Our example shows, in spite of the number of individual non-objective forms, how the impression of a landscape is unmistakably retained; the impression depends on the arrangement of the coloured areas which, 'in spite of severe offences against the rules of perspective do not in any way harm the spatial effects of the picture' (Gleizes). This special form of spatiality is brought to the middle of the picture by reduced forms, but without recourse to traditional perspective. These small areas give the impression of a view onto a town with houses, towers etc., lying further back, but the artist uses no other means to evoke

72

an impression of spatial distances. In his book *Du cubisme et des moyens de la comprendre* (Paris, 1920) Gleizes defined this reduction to flat forms as the only artistic means appropriate to painting.

The poet and critic André Salmon wrote a daily column on literature and art for Paris newspapers between 1909 and 1914. It was Salmon who in 1911 classed (in an article in the *Paris-Journal*) the work of **Metzinger** close behind that of Picasso and Braque, and this was in fact how the public thought of it. Up to this point Metzinger had exhibited at all the Salons, both at the time when he still painted in a Fauvist style and also when, after meeting Picasso and Braque, he became interested in Cubist techniques. At the Salon des Indépendants in 1911, of which he was the prime mover and where he also had a large number of his own paintings on show, the public accepted him as the leader of the new movement. This impression was helped by the fact that Picasso and Braque, who had been represented exclusively by Kahnweiler since 1907, did not show at this Salon. Nowadays Metzinger is best known for the book he wrote together with Gleizes (Ill. 40), *Du Cubisme* (Paris, 1912), the first major publication on the new movement by practising artists. Metzinger, who had started as a writer and an artist, had published poems in a number of journals. He had also contributed occasional articles on artistic questions, for instance 'Cubism and Tradition' in the *Paris-Journal* in 1911. He says there that Cubist painters are concerned with a 'pure and genuine art'. They have given up any idea of painting as a 'more or less modified form of photography'. Instead, they have 'allowed themselves to move about the object, in order—under the control of reason—to represent it concretely, from several sequential viewpoints ... for example, they draw the eyes in a portrait from the front, the nose in three-quarters profile and the mouth in profile. This way it is possible to reproduce likeness to an extraordinary degree, while simultaneously showing the right way forwards at a crossroads in the history of art'.

If one applies this to Metzinger's *Woman with Guitar* reproduced on this page, one at once sees a frontal view of a woman sitting and holding a guitar. On closer inspection, however, the frontal view reveals a woman in profile. The head of the figure is designed by means of light and shade to give this dual effect. The same ambiguity is observable in the shoulders and the breasts. Whereas the founders of Cubism, Picasso and Braque, were primarily interested in creating a

pictorially autonomous composition, in which the naturalistic content was at the most a secondary detail, Metzinger tried to produce a Cubist picture by combining views which essentially obey the traditional norms of art, and by using angular shapes.

41 Jean Metzinger
Woman with Guitar
Oil on canvas, 100×73 cm
Grenoble, Musée des Beaux-Arts

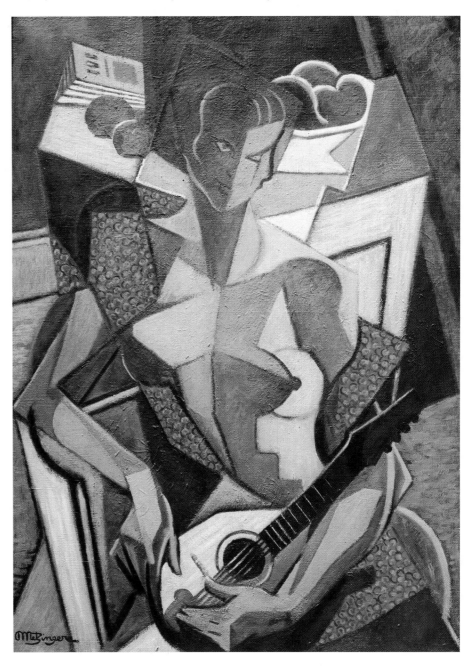

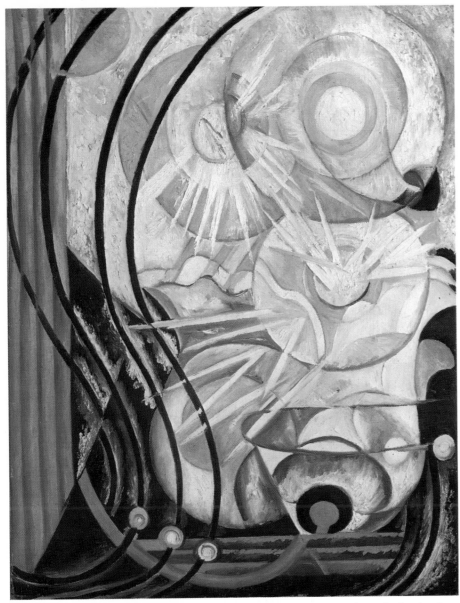

Together with Countess M. von Verefkin, who worked for a time with Gabrielle Münter in Munich, and Sonia Delaunay-Terk (Ill. 30, 31), the wife of Robert Delaunay (Ill. 27–29), Natalia **Goncharova**, grand-daughter of the Russian poet Alexander Pushkin, is one of the most important women painters of the artistic avant-garde at the turn-of-the-century. The Russian David Burliuk, who was associated with the Blaue Reiter in Munich and who wrote an article on the 'Russian Fauves' for the review of the same name edited by Kandinsky and Marc (1912), arranged a discussion on contemporary art in the same year for the second exhibition of the Karo-Bube Artists' Association in Moscow. Goncharova and her teacher and husband Larionov left the Association since they considered Burliuk to be a 'decadent imitator of the Munich crowd'; they also rejected the 'Paris lackeys', the followers of Cézanne. In this way they hoped to dissociate themselves completely from western European models. Under the title 'Donkey's Tail' Larionov organized an exhibition which opened on April 11 of the same year, and which presented Goncharova, Larionov, Malevich (Ill. 43, 44) and Tatlin for the first time as the 'Big Four'. Several influences are apparent in Goncharova's works, for instance Primitivism, the Russian variant of Expressionism which came into being in about 1907, and which explicitly draws on Russian folk art because of its preference for simple motifs—for instance, themes from everyday life (*Grain Harvest*, 1910; *Fishing*, 1910; and *Peacock in Bright Sunlight*—'in the Egyptian Style', 1911, and so forth). She also shows a unique combination of Cubism and Futurism which, with certain hieroglyphically esoteric elements, contributed to the rise of Russian Cubo-Futurism. Another characteristic of her work, which appears in our example, is a preference for technical devices and machines as motifs, for instance *Dynamomachine* (1909–1910) or *The Engine of the Machine* (1913). *Electric Lamps* belongs, in conception and composition, among Goncharova's Rayonnist paintings, which she produced from 1901–1910 onwards. In 1913, together with Larionov, she published the Rayonnist Manifesto which had been written a year before. Among its most important declarations are the following: 'The style of Rayonnist painting promoted by us is concerned with spatial forms which are obtained through the crossing of reflected rays from various objects, and forms which are singled out by the artist. The ray is conventionally represented on the surface by a line of colour. The essence of painting is indicated in this combination of colour, its saturation, the relationships of coloured masses, the intensity of surface working. The painting is revealed as a skimmed impression: it is perceived out of time and in space . . . painting is parallel to music while remaining itself. Here begins a way of painting which may be pursued only by following the specific laws of colour and its application to canvas. . . . From here begins the true freeing of art; a life which proceeds only according to the laws of painting as an independent entity, painting with its own forms, colour and timbre' (Gray, *op. cit.*, pp. 139–141). The motifs of our example accord very well with the Rayonnist requirements for composition. The coloured elements are concentrated in rays so that the construction of the picture is governed by almost prismatic effects which give the surface its dynamic appearance.

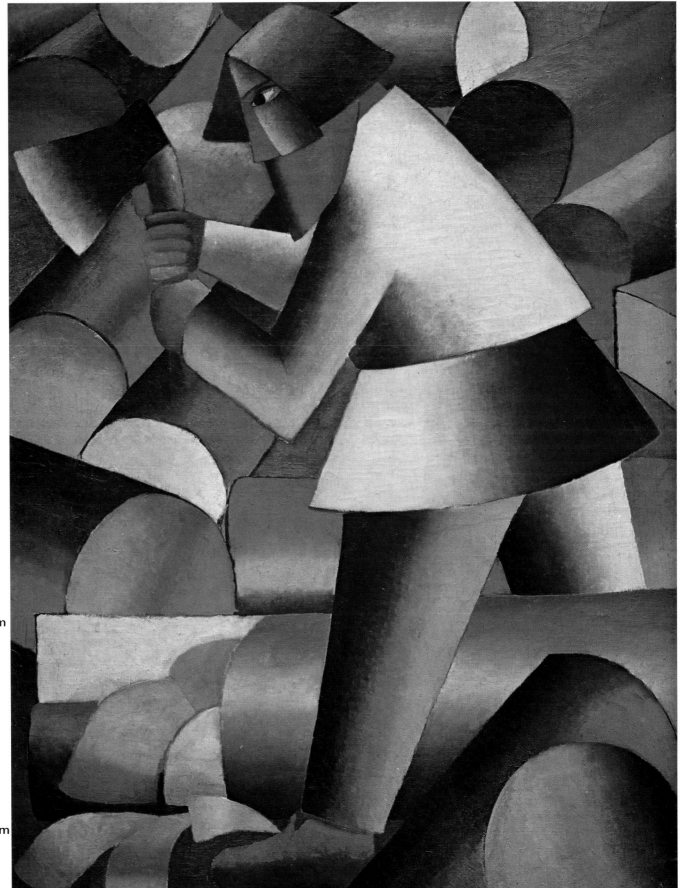

Left:
42 Natalia Goncharova
Electric Lamps,
c. 1911/1912
Oil on canvas, 105×81 cm
Paris, Musée National
d'Art Moderne

43 Kasimir Malevich
The Woodcutter, 1911
Oil on canvas, 94×71.5 cm
Amsterdam,
Stedelijk Museum

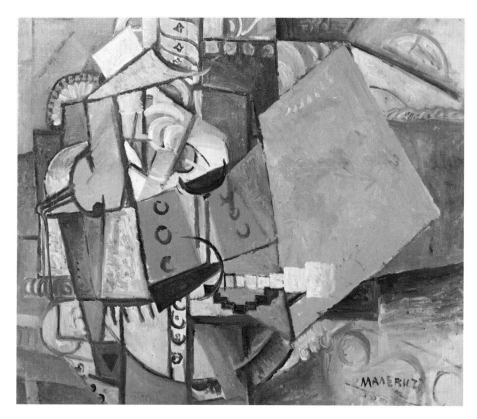

44 Kasimir Malevich
The Guardsman, **1912/1913**
Oil on canvas, 57×66.5 cm
Amsterdam, Stedelijk Museum

On first seeing **Malevich**'s *The Woodcutter*, it is hard to believe that this Russian painter is among the most significant precursors of abstract art. The most important stages through which he passed on the way to non-objective painting (which depends on geometric fundamentals) were represented by Impressionism, Fauvism, and the Russian version of Expressionism—Primitivism, in which he was associated with Goncharova (Ill. 42) and Larionov. Like those artists, he turned against academic tradition, and Symbolist and Art Nouveau painting, as represented in Russia mainly by the Blue Rose and Mir Iskusstva groups. He also became deeply interested in Cubism and Futurism.

With the co-operation of Larionov, the journal *The Golden Fleece* mounted an important exhibition of French and Russian painters and sculptors in Moscow in 1908.

The emphasis was on post-Impressionism and Fauvism. Not only works by Bonnard, Cézanne (Ill. 1–3), van Gogh, Matisse, Vallotton, Maillol and Rodin (to name only a few) were to be seen there. There was also Braque's *Grande Nue* (1908) and one of his early Cubist still lifes. Malevich was very much influenced by this and the next two exhibitions organized by the same paper in 1909.

Thematically, *The Woodcutter*, like similar topics in Goncharova's work, derives from Primitivism. The peculiarly cylindrical forms, which are also to be found in *The Harvest* (1911), *Woman with Buckets* (1912) or *Morning after a Snowstorm* (1912–13) bear witness to Malevich's encounter with Cubist forms and ideas. In addition the isolation of a single figure so as to dominate picture and surface, and the approximation of figure and ground achieved by the similarity of the cylindrical forms over the entire picture area, very clearly show Malevich's encounter with the pictorial techniques of early Cubism. *The Guardsman*, on the other hand, belongs to the combination of Cubism and Futurism developed mainly by Russian artists and known as Cubo-Futurism.

Malevich took part in 1910 in the first exhibition of the Karo-Bube which, like the 1911 exhibition, made a decisive contribution to the spread of Cubism in Russia. He was interested in Futurist notions of painting and showed some graphic work at the second Blaue Reiter exhibition in Munich in 1912. In 1913 he designed sets and costumes for the Futurist opera, *The Defeat of the Sun*, by Kruschonich and Matyushin, which had its première in Moscow. In the same year he attended the Futurist congress at Usikirki in Finland, parted from Goncharova and Larionov and began to develop quite independently from the methods of Rayonnism. His increasing stress on the aesthetics of pure painting finally led him to reduce the basic elements of painting to their 'zero point'. His image of 'nothing' is a black square on a white ground. For him the essentials of the Cubist picture were to be found in its dissection of reality as represented by the object, and therefore he tried to express non-objectivity itself. For this purpose he separated painting from the artistic activity, so that an intended dot or an intended form is distinguished from a non-intended environment. This approach to art is best compared with an infant's form of discrimination when it uses a very basic sound to stand for a number of objects, whether mother, ball or cooker. Malevich discarded differentiation within objects in order to portray non-objectivity.

In this 'complete liberation from the object' Malevich saw a 'new painterly realism' which he called Suprematism. He stressed the supremacy of pure sensation over all other representations of the visible world: 'Suprematism, as non-objective, white equality, is my approach to the goal towards which all concerns of practical realism must be directed, for it holds the essential object of human aspiration (Malevich, *op. cit.*).

Mondrian saw Cubist paintings by Picasso and Braque for the first time in Amsterdam in 1911. He visited Paris the same year. At this time, according to the composer J. van Domslaer, who had been a close friend since 1913, Mondrian was painting nothing but trees, 'abstract trees'. Starting from various parts of a tree, from the trunk, branches and twigs, which he painted on a uniform background, Mondrian, in paintings such as *The Grey Tree* (1912), found a way of combining figure and ground that he thought enabled him increasingly to discard the imitative notion of art. In *Composition with Trees II* (1912–1913), and in the painting illustrated here, the imitative function of the means used to depict the tree motif has been so suppressed in favour of autonomous ends that the often oval picture area may be said to have reached a fairly high level of abstraction.

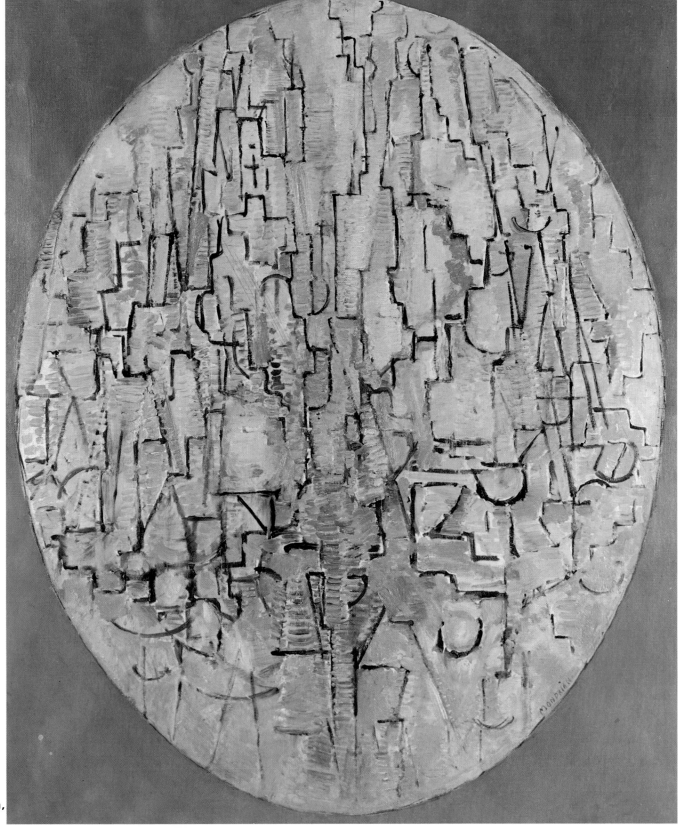

45 Piet Mondrian
Composition in an Oval,
1913. Oil on canvas,
94×78 cm. Amsterdam,
Stedelijk Museum

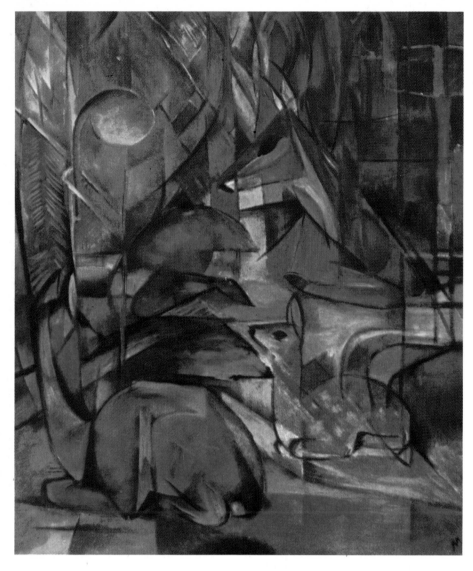

46 Franz Marc
Deer in the Forest, II, **1913/1914**
Oil on canvas, 115 × 101 cm
Karlsruhe, Staatliche Kunsthalle

After Wassily Kandinsky, Franz **Marc** was the most important member of the Blaue Reiter Expressionist group in Munich. At about the end of 1910 'Cubist angles' appeared in his paintings for the first time. In *Der Sturm III* of October 1912 Marc published an article on the Futurisl03ts in which he was most probably concerned with the Munich rather than the Cologne Futurist exhibition. If we add Delaunay's Orphism to the list we have all the major elements of Marc's art. Marc was never a pure stylist.

Animals became more and more the main theme of his painting, since human beings seemed to him increasingly alienated under the private and social conditions of the period. Marc wanted to achieve an 'animalization of art'. For him the animal was the image of life. He described his relation to animals and nature in a letter to the publisher R. Piper on April 10, 1910: 'I am trying to increase my sensitivity to the organic rhythm of all things; I am trying to empathize pantheistically with the singing and flowing of the blood in nature, in trees, in animals, in the air—I am trying to turn that into a picture, with new movements and with colours which refute our old easel-pictures'.

In *Deer II* three animals are related in a

pattern in which the countryside—trees, foliage and forest—or a dark sky, and the bodies of the deer are transformed by the artist into a new nature in which there is no longer any colour specific to an object, but where the colour composition is for the first time chosen by the painter. Hence the colours are not, as with Delaunay (Ill. 27–31), free and mutually supportive or reductive values—pure 'visibility values'. Instead the artist ascribes new colours to the objects in the environment he has brought into being, and thus connects them all in pictorial unity. In the process the transparency of the colours seems to give the spectator a certain insight into the interior of this animal kingdom. Kandinsky said of Marc's procedure: 'In his pictures the animals are so integrated with the "landscape" that in spite of their abstract "expressiveness", their Marc-like touch, they are only an organic part of the whole. . . Hence Franz Marc never became an "animal painter" or a "naturalist" and still less a "Cubist"—terms . . . often applied to him'.

On 27 October 1913 the first Synchromist exhibition opened at the Galerie Bernheim-Jeune in Paris. Two young Americans, Stanton **MacDonald Wright** and Morgan Russell, had chosen the name Synchromy for their artistic method which was obviously influenced by Delaunay's Orphism (Ill. 27–29), Kupka (Ill. 36, 37), and Picabia (Ill. 22). They described their intention in painting thus: 'We want to express and reveal the qualities of form by means of colour. Here, at this exhibition, colour plays this part for the first time. The painter must penetrate the occult relations between colour and form'.

MacDonald Wright organized his 'Synchromy' so that the 'colour-events' occur in front of a muted colour area and concentrate on the central verticals of the picture. The spectator, instead of responding to mutually supportive or reductive 'visibility values', may associate initially with the colour-forms of buds, blossoms and artistic handiwork (fans, pearls, and so on). Such associations make Wright's colour quite different from Delaunay's. Wright's are colour essays, and cannot escape their illustrative function.

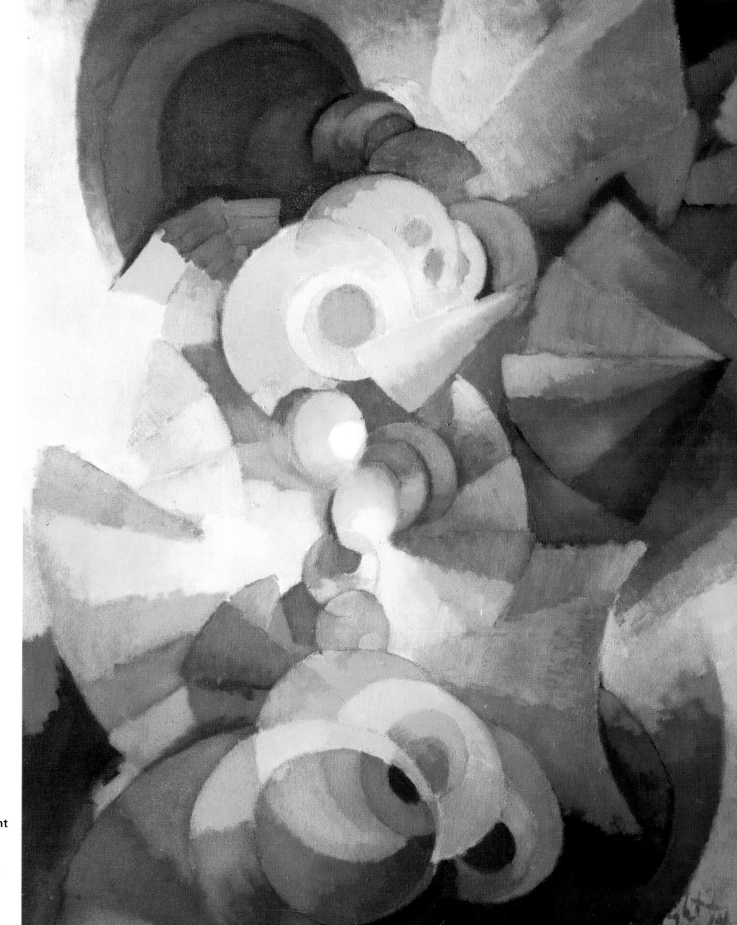

**47 Stanton
MacDonald-Wright**
Synchromy, **1914**
Oil on canvas
79 Private Collection

48 Giacomo Balla
A Child Runs along the Balcony, **1912**
Oil on canvas, 127.5×127.5 cm
Milan, Galleria Civica d'Arte Moderna,
Grassi Collection

If we move from the Cubism of Paris to the paintings of the Italian Futurists, our approach must change profoundly if not fundamentally. In spite of obvious influences from the French artists, and in spite of the direct connexions between Cubism and Futurism, Futurism was a movement in its own right. A major reason for this was the different social and cultural environment of the Futurists, which gave rise to different notions of art and to other aims in painting. We cannot turn away from Cubist canvases and use the same approach towards Futurist structures. The pictures we have chosen make this very clear.

There are very few Futurist paintings in

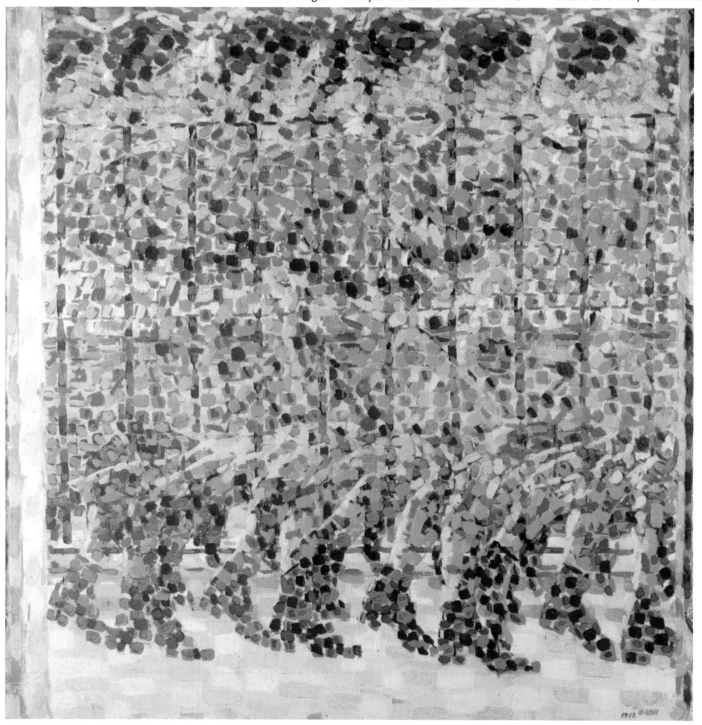

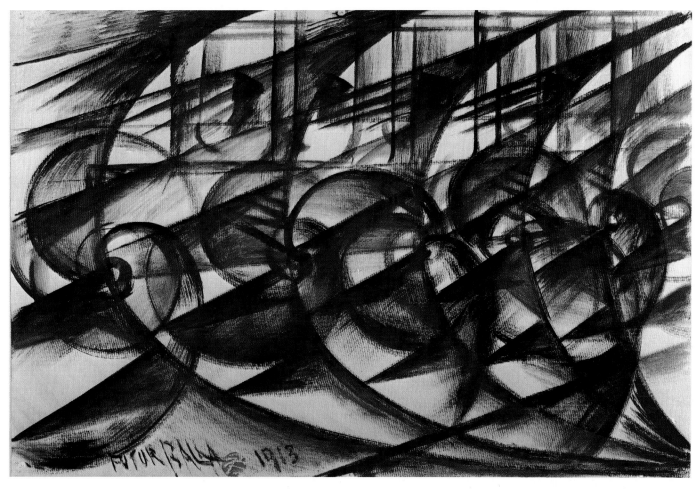

museums in the English-speaking world. Important paintings which Futurism contributed to the Modern Movement have completely disappeared as the result of wars and wear. Many sculptures, especially the very fragile *assemblages*, were destroyed. It is almost impossible to mount a satisfactory and comprehensive Futurist exhibition nowadays, since most of the major works are in public collections with the proviso that they shall never be moved for exhibition elsewhere, and private collectors are increasingly wary of letting these delicate works out of their hands.

Balla, who was largely a self-taught painter, initially painted cityscapes and socially-relevant portraits after his return from Paris in 1910. His point of departure was the Divisionist method which required the colour to be applied in a dense sequence of similar dots. He was influenced and encouraged by his pupils and friends, above

all Boccioni (Ill. 51–54) and Severini (Ill. 58–60), and in May 1912 painted his first Futurist picture, the now famous *Rhythmic Movement of a Dog on a Lead* (Ill. 30 in Apollonio, *op. cit.*). In 1912 and 1914 the painter visited Düsseldorf three times in order to paint the interior of the Loewenstein house. There he produced the first works of major importance for the development of modern art from Futurism to concrete abstractionism: the famous *Studies of Iridescent Compenetrations*.

The picture *A Child Runs Along the Balcony*, painted in the same year as *Rhythmic Movement of a Dog on a Lead*, shows Balla trying to add something to the sense of movement conveyed by the analytical process of photography. He wanted to add a new suggestion of motion by using means proper to static painting. Balla was influenced by the chrono-photographs of Marey which broke down

49 Giacomo Balla
Speed of a Motor Car, **1913**
Tempera, watercolour and ink
on canvas, 70×100 cm
Amsterdam, Stedelijk Museum

movement into measurable phases—and which, together with Muybridge's similar photographs, had a big influence on Duchamp (Ill. 39), Villon (Ill. 33), and Kupka (Ill. 36, 37). He tried to find a painterly equivalent for the photographs, which had been made for scientific rather than aesthetic purposes.

In *Rhythmic Movement of a Dog on a Lead* the parts which indicate movement (feet and tail) and the lead itself are multiplied so as to give the impression of continuous movement, rather than a picture of the dog's movements at different points, as in a series of photographic stills. The similarity to a photograph is also evoked by a

composition inconceivable without the history of photography: the dog is in the middle, and above there are feet and a woman's dress—it is the snapshot technique transferred to painting. The colour deliberately gives the impression of a big monochrome still.

In *A Child Runs Along the Balcony*, on the other hand, the observer's eye is helped to follow the figure, which is repeated across the surface of the canvas in imitation of movement, by the contrast between the large number of metal verticals on the balcony. These emphasize all the static, vertical aspects of the painting, and the fact that the figure is in different phases of one

50 Giacomo Balla
Speed of a
Motor Car + Light + Sound, **1913**
Oil on canvas, 87×130 cm
Zürich, Kunsthaus

movement. The observer is further helped by other details, such as the figure's head, arms and legs, and above all the floor, against which the feet are seen to rise and fall in such a way that for the observer's eye the movement from the left begins with rising feet and ends on the right when a foot is firmly placed on the floor of the balcony.

Balla connects the phases of movement in a sequence of large colour *taches*, applied in a manner reminiscent but significantly different from that of the French Divisionists.

In *Speed of a Motor Car* and *Speed of a Motor Car + Light + Sound* verticals are also used to allow the spectator a number of stable lines of direction. In *Speed of a Motor Car*, the observer is 'approached' by a number of arc- and spiral-like devices, rotating and interpenetrating, and ultimately angular. Closer examination reveals the outline of a car with possibly several passengers, or only one, in which case the

painter has subjected the car to the same kind of 'photographic shutter' effect as the child in the previous picture and the verticals in the upper part of the painting are the car's window frames. The spiral movements in the picture clearly emanate from the wheel-hubs. In *Speed of a Motor Car + Light + Noise*, Ball discards this mimetic approach. Here he is much more interested in portraying the dissociated dynamics of a 'car' by manufacturing, on the surface of the canvas, a colour-and-form device which evokes movement. Almost mother-of-pearl light effects heighten the simultaneity and ubiquitous presence of the device in the picture. This effect is not countered but heightened by the directional contrast of verticals which divide the canvas into smaller areas.

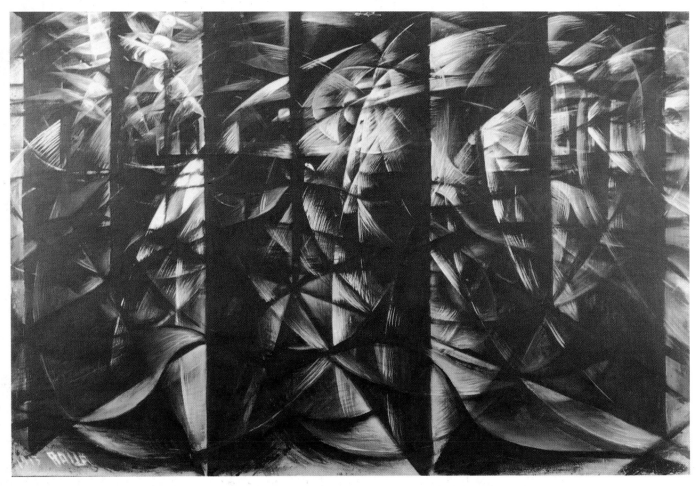

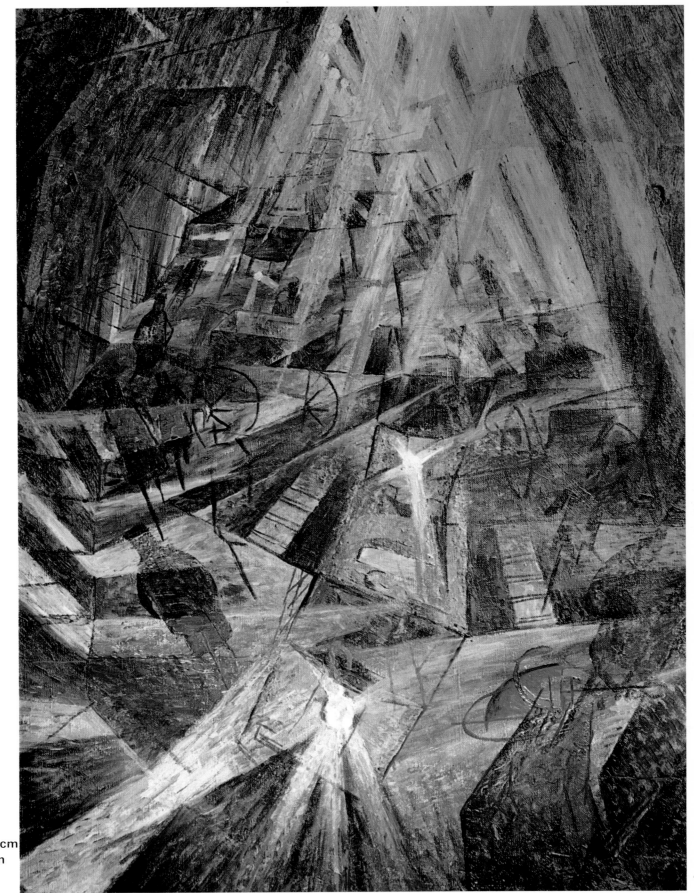

51 Umberto Boccioni
Forces of a Street, **1911**
Oil on canvas, 100×81 cm
83 Basle, Private Collection

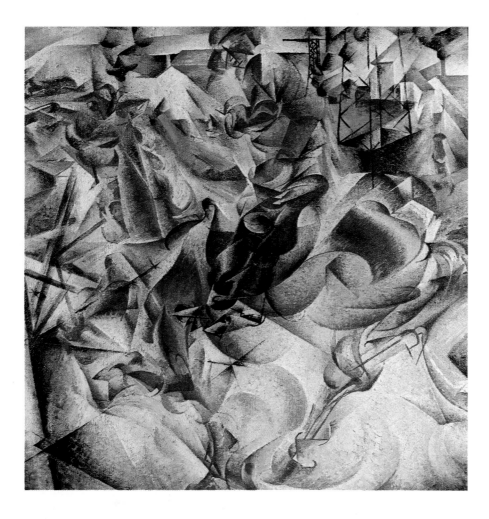

52 Umberto Boccioni
Elasticity, **1912**
Oil on canvas, 100×100 cm
Milan, Collection Dr Riccardo Jucker

Boccioni wanted at first to be a writer and composed an unpublished novel, *Pene dell'Animo*. He also worked as a journalist, and is rightly thought of as the 'theoretician' of Futurist art. He wrote *Futurist Painting: A Technical Manifesto* (April 11, 1910), and the foreword to the catalogues of the exhibitions of the works of Futurist painters that took place in 1912 in various European cities, for instance in London (Sackville Gallery), in Paris (Galerie Bernheim-Jeune), Berlin ('Der Sturm' Gallery), Amsterdam and Brussels. His essays on dynamics in art appeared from 1913 onwards in the journal *Lacerba*. In 1914 they were published in book form under the title *Futurist Painting*

and Sculpture (*Pittura e Scultura Futuriste*). An important date in his evolution as a Futurist painter is the year 1911 when he accompanied Carrà (Ill. 55–57) and Russolo (Ill. 61–64) to Paris. In Paris the three painters met Apollinaire, and of course Braque (Ill. 10–16) and Picasso (Ill. 4–9). Boccioni, who from 1910 to 1915 participated in all the major Futurist exhibitions, was always interested in spreading Futurist ideas and theory, and did so on his visits to the various cities where the shows were held; he travelled with Marinetti, that other propagandist and tireless pacemaker of Futurism.

Boccioni was more insistent than any other Futurist on developing the theme of movement in painting by forcing the spectator uncompromisingly, through various devices, to perceive speed, rhythm and beat. He wrote in his *Technical*

Manifesto: 'The structure of pictures is ludicrously conventional. Painters have always been intent on showing us things and people by setting them before us. We, however, put the spectator right into the picture' (Apollonio, *op. cit.*). In *The Noise of the Street reaches into the House* Boccioni gave a superb example of this intention in his own work. At first sight the picture seems to be no more than a conventional representation of a view from a balcony onto a rather lively street-scene. The figure looking out is foreshortened by the lower edge of the painting; she is balanced to some extent by a figure on the left-hand side doing exactly the same thing. If we look carefully we can see a third person looking into the street just beyond the central spectator's right shoulder. These two onlookers, and indeed all the other figures in the picture, are much smaller than the spectator in the foreground. In 1912, the year in which he painted the picture, Boccioni wrote in his foreword to the catalogues for the Futurist exhibitions: 'In painting a person on a balcony, seen from inside the room, we do not limit the scene to what the square frame of the window renders visible; but we try to render the sum total of visual sensations which the person on the balcony has experienced; the sun-bathed throng on the street, the double row of houses which stretch to right and left, the beflowered balconies, and so on. This implies the simultaneousness of the ambient, and, therefore, the dislocation and dismemberment of objects, the scattering and fusion of details, freed from accepted logic, and independent from one another. In order to make the spectator live in the centre of the picture, as we express it in our manifesto, the picture must be the synthesis of *what one remembers and of what one sees*' (Sackville Gallery catalogue, London Futurist exhibition, 1912).

If the spectator responds to the optical demands of the picture, and puts himself in the place of the quite realistically depicted spectator-figure in the painting, then he is 'living in the centre of the picture', an intention stressed and aided by the intersection of the two diagonals in the picture—the format of which deviates only minimally from the

84

square. It is of great importance for the Futurist technique of the work that the painted spectator should bend a long way over the balcony to reach into the 'atmosphere' of the street itself. The analysis and breakdown of the animals, people and houses, which are still essentially imitative, follow the 'lines of force' showing the inherent movement of coloured forms, the dynamic visualization of form, and constitute the constructional lines of the objects themselves. Boccioni himself wrote: 'The frame of an open window becomes an *irregular, changeable entity*, into which external things are incorporated by means of the atmosphere: this in turn penetrates into the room in such a form as has been given it by the potential shape of the bodies without. Hence, we have a superb example of the interaction of the lines of force of things and those of the window, between which the conductor, the atmosphere, moves with the momentum and contraction of changing density'. Whereas, for instance, in

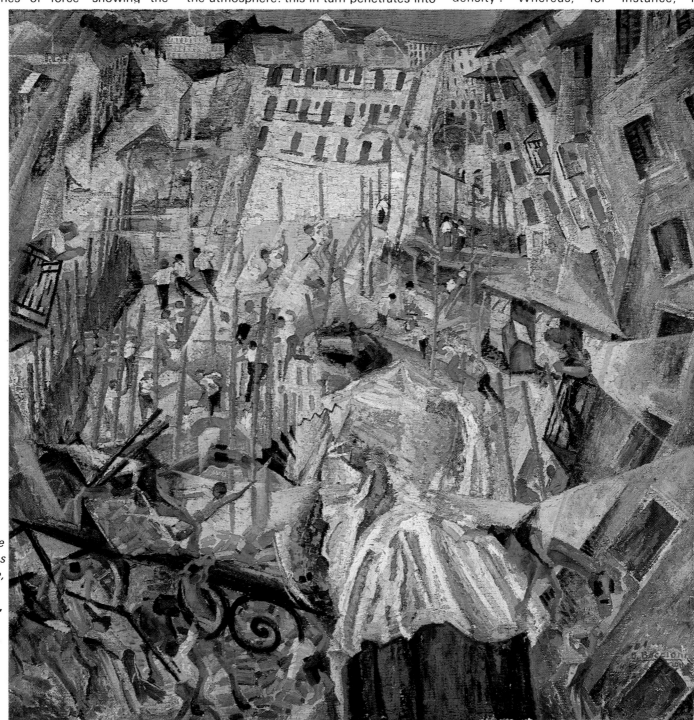

53
Umberto
Boccioni
The Noise of the
Street Reaches
into the House,
1912,
oil on canvas,
100×100.5
cm, Hanover,
Niedersäch-
sisches
Landes-
museum

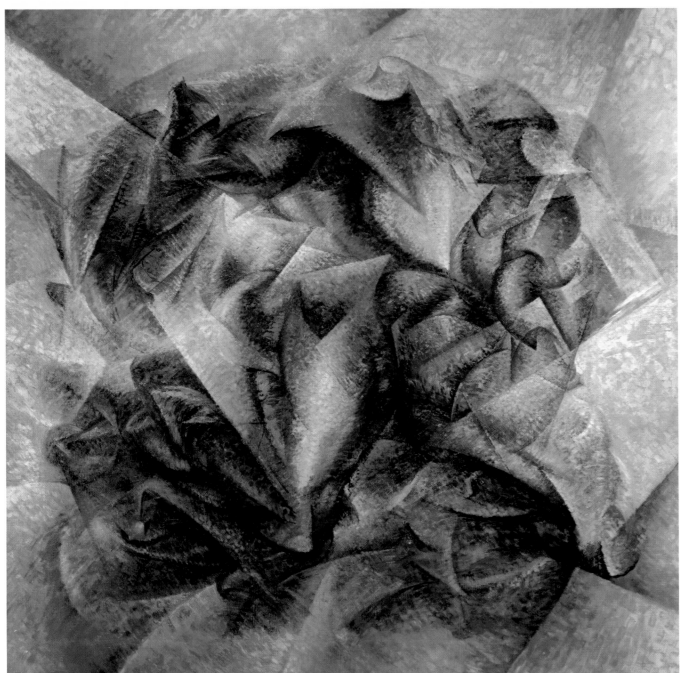

54 Umberto
Boccioni
*Dynamics of a
Footballer*, 1913
Oil on canvas,
197×201 cm
New York,
Museum of Modern
Art,
Sidney and
Harriet Janis
Collection

Delaunay's *View of the Eiffel Tower* (Ill. 27), the window frame is dispensed with, and only the curtains remain, in Boccioni's painting the painter has intentionally equated the window frame and the actual format of the painting.

If the spectator has indulged in the extremely active exercise of perception demanded by the organization of the picture, and in following the composition has acquired the requisite visual experience, he is in a position to decipher for himself what the painter is trying to do in *Forces of a Street*, *Elasticity* (indisputably one of the major works of Futurism), and *Dynamics of a Footballer*. He should discover that: 'For us the picture has ceased to be an external scene. It is not a stage on which the action takes place. For us the picture is an architectonic construction which can radiate appropriately, whose core is the artist and *not* the object. It is an architectonic environ-ment corresponding to the emotions, one which arouses one's sensibilities and sur-rounds the spectator. We ratify the object in the movement of its forces; we do not describe its unimportant aspects. . . And so we observe that the boundaries of the object tend to recede towards a periphery, or environment, the mid-point of which we ourselves are' (Boccioni).

In *Elasticity* the intention is that the spectator too should be displaced to the

centre of the picture by focusing on the darkest area of colour. From that point he can trace optically the way in which the pictorial forms chosen to represent flexibility or, rather, ductility radiate on all sides to the periphery of the painting; how angular areas and straight lines pointing in various directions meet in the marginal areas of the painting and interact with them so that finally, here too, the horizontals, verticals and angles of the picture's framework are themselves drawn into the dynamic composition of the whole. Boccioni himself declared that this interaction between contrasting forms was a fundamental painterly device of Futurism: 'Every form bears within itself a tendency to amplify itself by means of a complementary form, which is unconditional to the full expression of its particular nature (elliptical, angular, spherical, cubic, conic, and so forth) and to the full determination of its perspective (horizontal, vertical, diagonal, and so forth)'.

As the title of the painting, *Elasticity*, already makes quite clear, this dynamic composition is hardly interested in the very sketchy though obviously representational suggestions of a horse and its rider. Similarly, in *Dynamics of a Footballer*, the movement is not divided into a number of phases but, by means of the technique already described, is heightened until it becomes the dynamics of the picture itself.

In order to understand **Carrà**'s painting it is necessary to refer yet again to Boccioni's introduction to the catalogue for the Futurist exhibitions of 1912. There we read: 'You must render the invisible which stirs and lives beyond intervening obstacles, what we have on the right, on the left, and behind us, and not merely the small square of life artificially compressed, as it were, by the wings of a stage'. This attack on an art which is interested only in the spectator's vision was extended by Carrà in his *Manifesto of Painting, Sounds, Noises and Smells* (1913), in an attempt to promote a form of pictorial art that would engage, arouse and sensitize not only the eyes but all possible human senses. This idea of art, which looks on the

spectator not merely as a visually perceptive creature but as a sensual being *in toto*, is to be distinguished from the Cubist notion that contemplation of a painting should join sight and touch, for Carrà's Futurism adds hearing and smell to the list.

Until 1915 Carrà played an active part in the Futurist movement. He then adopted a somewhat more retrogressive style in painting, and after 1916 (he had met Giorgio de Chirico in a military hospital) turned to a form of metaphysical painting (*Pittura metafisica*).

In 1910–1911 Carrà painted the best-known portrait of the Italian poet and theorist E.F.T. Marinetti, the founder of literary Futurism who got the whole Futurist

movement off the ground and publicized it with the skill of a modern advertising agent. His *Manifesto of Literary Futurism* was published in 1909 in the Paris newspaper *Figaro*. Marinetti spent his youth in France and when in Milan kept in close touch with Parisian literary circles. He later became a convinced supporter of Italian Fascism.

The Futurist aspect of the portrait of Marinetti is its most obvious characteristic: Carrà shows the writer in the act of writing,

55 Carlo Carrà
Portrait of Marinetti, **1910/1911**
Oil on canvas, 90×80 cm
Private Collection

but interrupting it for a second in order to look up at the spectator. To do that he must have bent down from a higher level of the picture, and seems thus to be 'breaking out' of the surface. The colour of the painting is rather muted and shows the influence of neo-Impressionism.

In *The Red Horseman* Carrà makes use of

56 Carlo Carrà
Burial of the Anarchist Galli, **1911**
Oil on canvas, 199×259 cm
New York, Museum of Modern Art,
Lillie P. Bliss Bequest

pictorial techniques in a way already familiar to us from the practice of Balla (Ill. 48–50). The changing forms of horse and rider are essentially symbolic of action and movement and stand out against a light background, so that the dissection can be seen quite easily. The general theme is unmistakable, for the horse and rider have been sketched in a straightforward, almost naturalistic style but the elements indicating movement, such as the head and the front and back legs of the horse, as well as the rider himself, appear in the 'Futurist' detail. In the depiction of the horse, shown galloping, the legs and head are not in different phases of a single movement, but a mass of

blurs and hints faintly superimposed on the body of the horse and the rider. The hard, dark lines which accompany the horse and rider diagonally, already indicate the use of acute angles which was to become a typical directional device in later Futurist painting. Overall *The Red Horseman* gives one an impression that, as in the simultaneousness of perceived movement, on one spot and in a single moment of time, the horse's limbs have multiplied; it seems to be straining at some invisible aerial rope, anxious to gallop away as soon as the restraint disappears. Here Carrà is following the theories of the 1910 *Manifesto* (later rejected by the Futurists) that objects, things and figures in

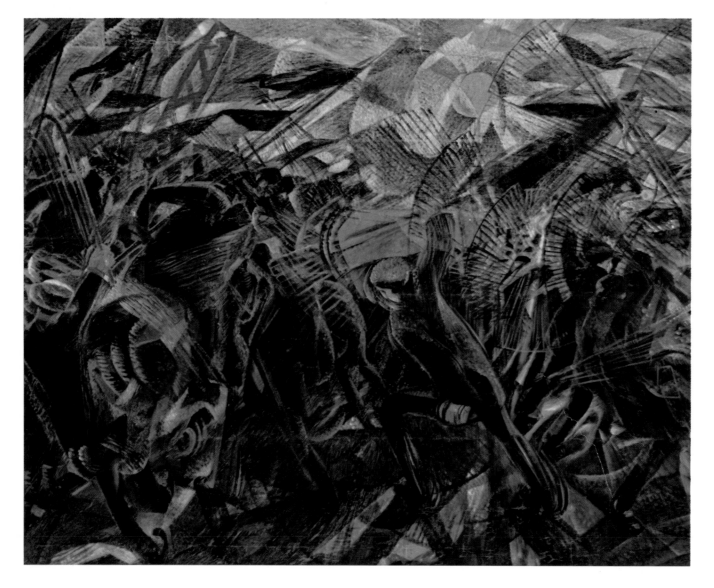

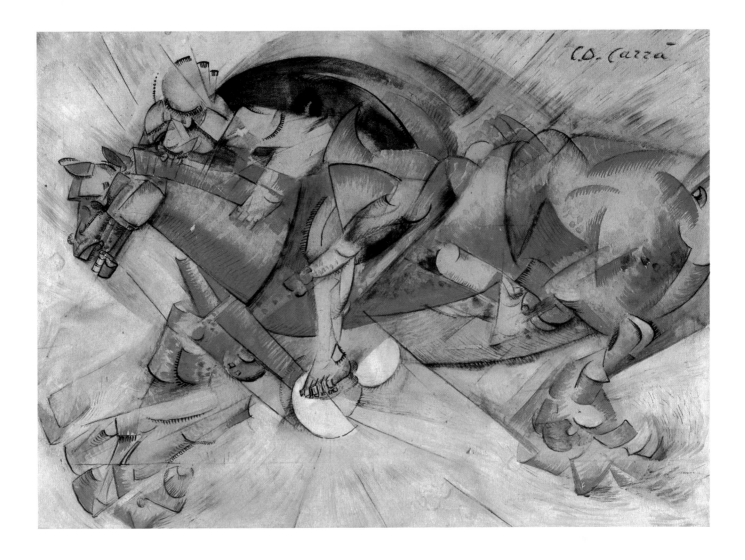

movement change their shape and follow one another like 'vibrations in space': 'Thus a running horse has not four legs, but twenty, and their movements are triangular.' Carrà exemplified his theoretical text by painting sounds, noises and smells in his own work *The Burial of the Anarchist Galli*. As he says in his text: 'We do not exaggerate when we opine that smells are enough in themselves to evoke sufficient arabesques of form and colour in our spirit to provide the motif for a painting and to justify the necessity of that painting. For instance, when we find ourselves in a dark room with flowers, petrol and other pungent or odorous things, and our visual sense is arrested momentarily by the darkness, then our pictorial imagination gradually eliminates sensations afforded by memory and produces a special complex imagery which harmonizes perfectly with the quality, weight and movement of the smells present in the room. By some unexplained process, these smells become a force-field and evoke that state of spirit and mind which for us Futurist painters represents a pure pictorial complex. This interplay of tuneful and fragrant forms and lights is something realized in part by myself in *Funerale Anarchico* (Ill. 56) and in *Sobbalzi di Fiacre*, by Boccioni in *Stati d'Animo* and in *Forze d'una Strada* (Ill. 51), by Russolo in *Rivolta* (Ill. 61), and by Severini in *Pan-Pan*—pictures which were hotly discussed at our first exhibition in Paris (February 1912). This effervescence of forms and colours presupposes an extraordinary form of arousal, almost a state of delirium, in the painter.

57 Carlo Carrà
The Red Horseman, **1913**
Oil on canvas,
Milan, Collection Dr Riccardo Jucker

We have used examples of the work of Balla (Ill. 48–50), Boccioni (Ill. 51–54) and Carrà (Ill. 55–57) to illustrate the representation of beat, turbulence and commotion in Futurist painting as an artistic activity which uses

58 Gino Severini
Blue Dancer, **1912**
Oil on canvas with sequins, 61×46 cm
Milan, Mattioli Collection

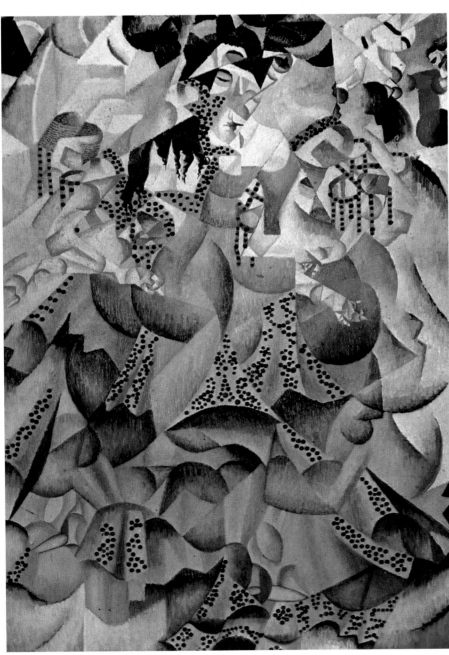

'interpenetrations' complementary to forms, or concentrates on the centre of the picture to put the spectator into it. But we have also seen that the Futurist method is to extend the contemplation of a picture beyond any mere visual reaction and to invoke the use of as many senses as possible. **Severini** added another technique to the Futurist repertoire with his use of analogy. In Marinetti's *Technical Manifesto of Literary Futurism* (1912) we read: 'Analogy is no more than

the profound love which joins distant, apparently different and alien things. Only by means of very extreme analogies can an orchestral style which is simultaneously polychromatic, polyphonous and polymorphous encompass the life of matter'.

The Severini exhibition held in the Museum-am-Ostwall in Dortmund, Germany, from March to April 1976, showed how the painter came under the influence mainly of synthetic Cubism, from about 1916. In 1918 Severini began to contribute to the journal *De Stijl*, the organ of the Dutch artists' group of the same name which formed around Theo van Doesburg, who also edited the paper.

Blue Dancer, Dynamic Hieroglyphs of the Bal Tabarin, and *Shapes of a Dancer in Light* belong to a series of paintings which are no longer concerned with a directly imitative reproduction of movement in the static medium of painting, but use painterly techniques to analyse and dissect colour and form in order to offer a pictorial representation of movement. For the Futurist Severini, the loose distribution of colour areas and planes was more significant than composition with volumes derived from geometry and stereometry. The artist used this procedure in order to put his idea of analogies in visual art into practice. In *Blue Dancer*, the spectator's attention is drawn first to parts of a woman's face, black hair, arms and a hand, and a sea-blue evening dress. In the top right corner of the painting, there are suggestions of onlookers. The dress areas are decorated here and there with sequins, as if to suggest that the painter could apply a 'sequin paint'. The arms are conceived physically and represent various positions in dancing. The chronological sequence is shown by simultaneity, superimposition, interrelation and interaction. The figure, whose dress projects somewhat towards the spectator and might even be frilled, dominates the surface of the painting, but is so broken-down that it recedes into a number of individually described planes and, in spite of the grey, white and ochre variations of the upper part of the picture, there is hardly anything approaching a background in the con-

ventional sense. If we look quickly at *Dynamic Hieroglyphs of the Bal Tabarin*, we see that the painter is trying to do something very similar and with the same techniques. Non-objective colour areas, sometimes 'inflated' like paper-bags, as in the *Blue Dancer*, are combined with objectively identifiable insertions, for instance in the top left corner of the picture there is a small female nude on a large pair of tailor's scissors, and, distributed along the upper edge of the picture, there are pennants in different national colours. Both kinds of colour area are interrelated with curves and angles, so the spectator will experience not only turbulence when he looks into the painting, but optical dissociation.

The peculiar nature of Severini's method of analogy becomes apparent when the spectator sees that the canvas *Blue Dancer*, in spite of the unambiguous title and the recognizable motif, can be seen in a quite different way. It also poses the question: Are there not, apart from the dancer, just as obvious indications of quite distinct objective conjunctions, which avoid any pure speculation? The spectator is helped by the assumption that, as in most Futurist paintings, the artist is not interested in the unique and original aspects of a person, scene or situation, but in the typical: for instance, a typical movement. The spectator, however, is required to perceive this typical instance in a new and individual way. What is typical in movement can be visualized just as proficiently in *Dynamic Hieroglyphs* and in *Shapes of a Dancer in Light*, as in *Blue Dancer*. Here, too, the painting is set in a frame onto which the painted forms extend like light rays, as if the picture areas were unable to restrain them in their depiction of movement. This device also serves the purpose (as would happen again later in modern painting) of making the format of the picture part of the picture's theme.

Severini's intentions become even clearer on reading the text he wrote probably between September and October 1913: *The Pictorial Analogies of Dynamism: A Futurist Manifesto*. We quote from the section in which Severini clearly refers to the paintings illustrated here:

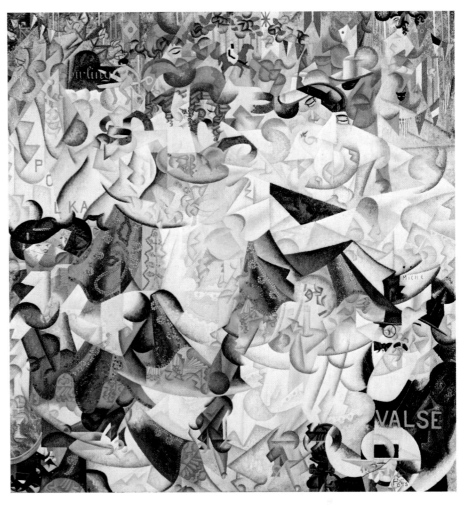

'There are two kinds of analogy: *true analogies* and *apparent analogies*. For example:

True analogies: the sea with its dancing-on-the-spot effect, its zig-zag movements, and its sparkling contrasts of silver and emerald evokes in my painter's sensibility the very far-off vision of a dancer in a sequinned dress, surrounded by light, sounds and murmuring voices.

Hence: *Sea = dancer*.

Apparent analogies: the pictorial aspect of the sea which by means of a true analogy evoked a dancer in me, also offers me initially, by an apparent or false analogy, the image of a large bunch of flowers.

Such apparent, superficial analogies help the painter to increase the expressive value of his work of art. Hence we have the following equation:

Sea = dancer + bunch of flowers'.

59 Gino Severini
Dynamic Hieroglyphs of the Bal Tabarin, **1912**
Collage, 161 × 156 cm
New York, Museum of Modern Art,
Lillie P. Bliss Bequest

91

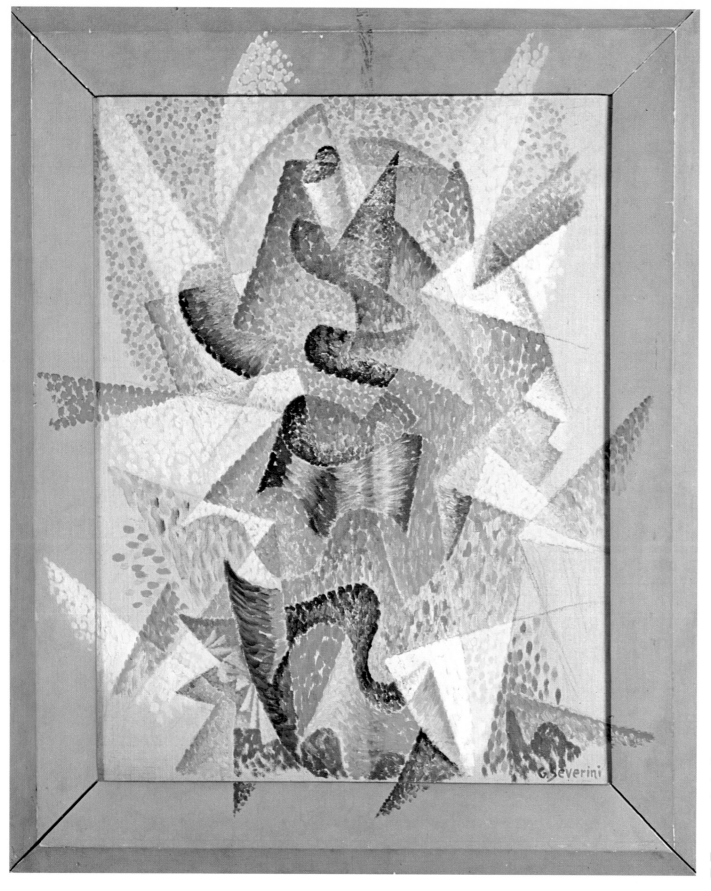

60 Gino Severini
*Shapes of a Dancer
in Light*
**1913
Oil on canvas,
71 × 56 cm
Rome,
Private Collection** 92

Russolo always knew that he was intended to be a painter although, as the son of an organist, he studied music first. On March 11, 1913 he published his first Futurist manifesto *The Art of Noises*, which is one of the most important texts of the entire Futurist movement. With his thesis that the noises of a modern city could approximate or even replace music, Russolo anticipated, long before the reality, major developments in modern music. He built noise instruments, for instance a 'rumorarmonio' or 'russolofono'. He wanted to use these noise instruments mechanically to combine the characteristic noises in their 'six families':

'1. Droning, thundering, bursting, rattling, plunking, throbbing;

2. Whistling, hissing, wheezing;

3. Whispering, babbling, buzzing, whirring, bubbling;

4. Cracking, creaking, rustling, humming, rattling, grating;

5. Noises produced by striking metal, wood, leather, stone, china and so on;

6. Animal and human noises: calls, cries, groans, roars, howls, laughter, rattles, sobs' (Apollonio, pp. 107 ff.).

It is not difficult to trace musical effects in Russolo's painting. Rhythm and beat are easily discernible.

The theme of *The Revolt* consists of two contrary movements. On the left edge of the picture we see first three reddish oblongs arranged one above the other; the perspective seems odd, even distorted, and they also grow smaller in relation to one another; from bottom to top. They are arranged in parallel and grow smaller along the upper edge of the painting until they disappear into the top right-hand corner. In the lower half of the picture, bottom left, there are some triangular violet shapes with dark window-like rectangles on them. There is a green piece with a dark circle on it. The observer

now begins to pick out in the weaker, unemphatic part of the picture, the roofs and part-façades of a series of houses whose recession into the depths of the painting provides the optical value. Whereas, in early Cubism, the Cubist devices are used against an imitatively intact basic structure (e.g., a figure), this early Futurist essay of Russolo's openly features an extreme stylization of the houses. This stylized form is repeated in order to portray not the houses but movement, arising out of similar forms repeated at certain intervals. This was a major step towards wholly non-objective, abstract art.

A counter-movement is produced by the rush of figures from the depths on the right and turning into a red wedge advancing

61 Luigi Russolo
The Revolt, **1911**
Oil on canvas, 150×230 cm
The Hague, Gemeentemuseum

62 Luigi Russolo
Houses + Light + Sky, **1912/1913**
Oil on canvas, 100×100 cm
Basle, Kunstmuseum

across the canvas, and by the red passages revealed as it were behind or across the houses. The arrow and wedge shapes add to the forceful movement towards the left-hand edge of the painting. This movement is accentuated by the bright yellow-green wedge which serves in fact to push the red

further to the left. As with Cézanne (Ill. 1–3) and in Delaunay's Orphism (Ill. 27–29), the colours are used as pure visual counters. Russolo and, for instance, Balla in *Speed of a Motor Car* (Ill. 49) and *Speed of a Car + Light + Sound* (Ill. 50), as well as Boccioni in *Forces of a Street* (Ill. 51), attempt to use

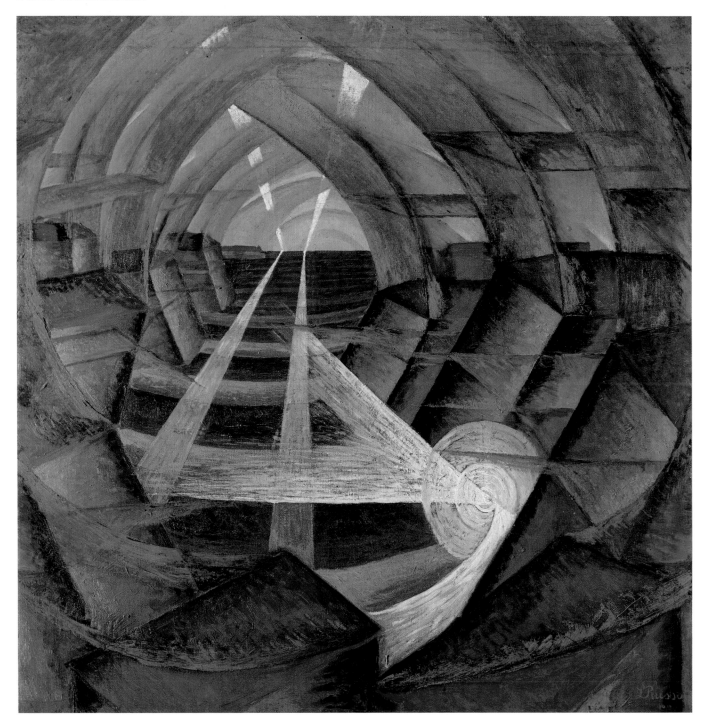

arrows and triangles as pure directional devices or values embodied in the pictorial forms of colour and line. But the painter is really only able to portray the inward as well as outward dynamism of a revolutionary process in the static medium of painting by referring the observer to his everyday mode of perception. To do this he gives a topical, figurative emphasis to the dynamic process unleashed in the picture. He makes it visually clear to the spectator that a crowd of people is advancing to become a force-field. In this way he makes the impression, as well as the idea, of pressing forward and repelling inescapable. The observer is forced to associate the red wedge and the forwards-advancing crowd with ineluctable force and counter-force, weight giving in before force, and thereafter to view the picture as a representation of pressure and counter-pressure. In this way the picture becomes a major expression of revolution in modern art without needing any ideological exegesis or overlay.

Russolo's technique and general approach in *Houses + Lights + Sky* and *The Solidity of Fog* are closest to Boccioni's in *The Noise of the Street Reaches into the House* (Ill. 53). In his two pictures, Russolo is not interested in the visual rendering of a linear movement from one position to another, something we are used to visually in our everyday experience. Instead he builds up an energetic tension over the entire area of the picture which either proceeds from or towards one point. In both pictures these points are shown as circles surrounded by concentric rings. In both figures these points are approached by acute angles which are darker or lighter. The angular forms are to be taken either as guidelines for the light directed away from the spectator, or as devices which turn it towards him. In each case they make him an essential component of the pictorial action. In *Houses + Lights + Sky* there are two points on the horizon; in *The Solidity of Fog* the place in question is the brightest point of the light-source. Both pictures are also designed so that three connected and interactive fields of movement are set up.

In *Houses + Lights + Sky* the red and

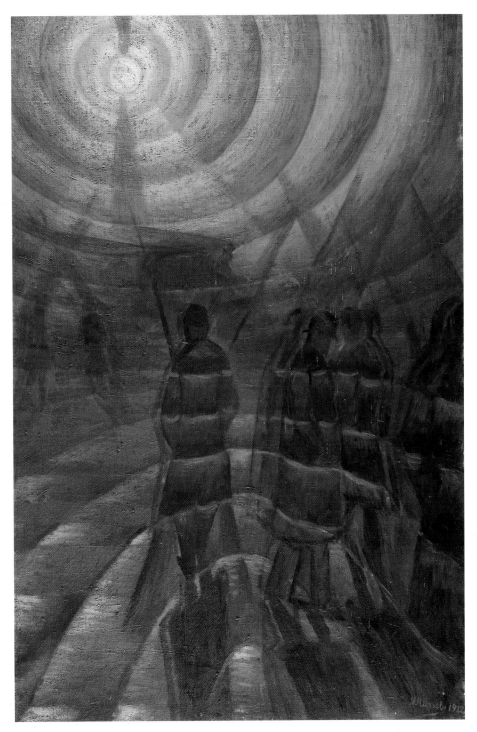

purple masses which are so reminiscent of Braque's *Houses at L'Estaque* (Ill. 12) and which are toned down with dark hatching, stand for houses; the blue arcs represent the sky; and the circles and rays are light.

The Solidity of Fog sets up an interaction between the dark area of a vaguely sketched

63 Luigi Russolo
The Solidity of Fog, **1912**
Oil on canvas, 100×65 cm
Milan, Mattioli Collection

landscape, a small group of people and light breaking through fog. In both pictures the optical weight is moved to the edges to avoid any suggestion of a uniform, conventional use of perspective. Of course the spectator is allowed, indeed required, to react to a suggestion of traditional perspective, but if he tries to pursue it he will find it impossible. The artist uses the typical Futurist trick of drawing the spectator optically into the picture while at the same time making the subject of the picture appear to step out and come towards him.

64 Luigi Russolo
Dynamism of an Automobile, **1911**
Oil on canvas, 106×140 cm
Paris, Musée National d'Art Moderne

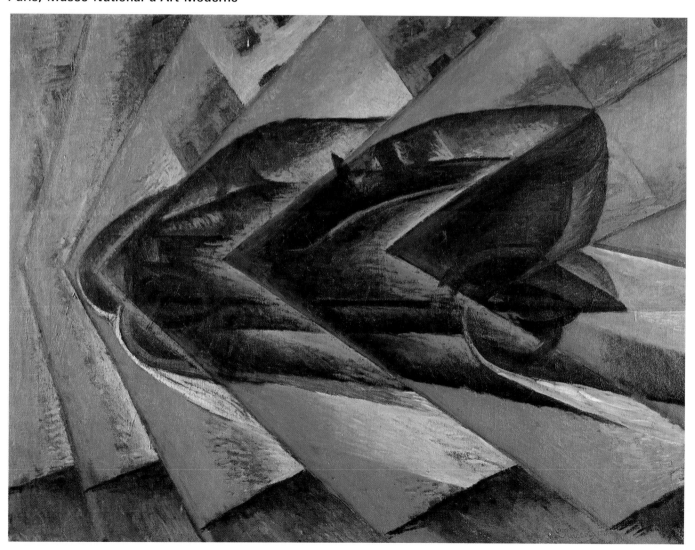